# WHEN WINTER WAS KING

Published in conjunction with the exhibition *When Winter Was King*, an official
presentation of the XV Olympic Winter Games held in Calgary, Mt. Allan, and Canmore, Alberta

EXHIBITION DATES:
Whyte Museum of the Canadian Rockies, Banff, Alberta
January 26 - March 6, 1988
London Regional Art Gallery, London, Ontario
April 9 - May 24, 1988
Art Gallery of Windsor, Windsor, Ontario
June 4 - July 10, 1988
McCord Museum, Montreal, Quebec
September 16 - October 31, 1988

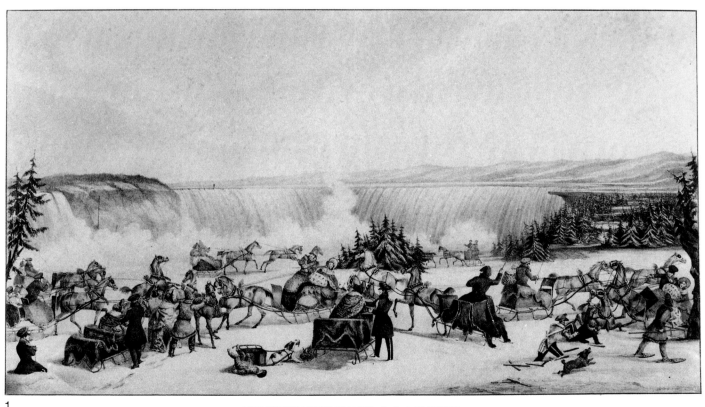

1

LIEUTENANT RICHARD G.A. LEVINGE
**The "43rd Light Infantry" as they "Turn Out" in their Sleighs;
at the "Falls of Niagara"**
1839, coloured aquatint, 48.3 × 70.7 cm.
National Archives of Canada, Ottawa (C-4983)

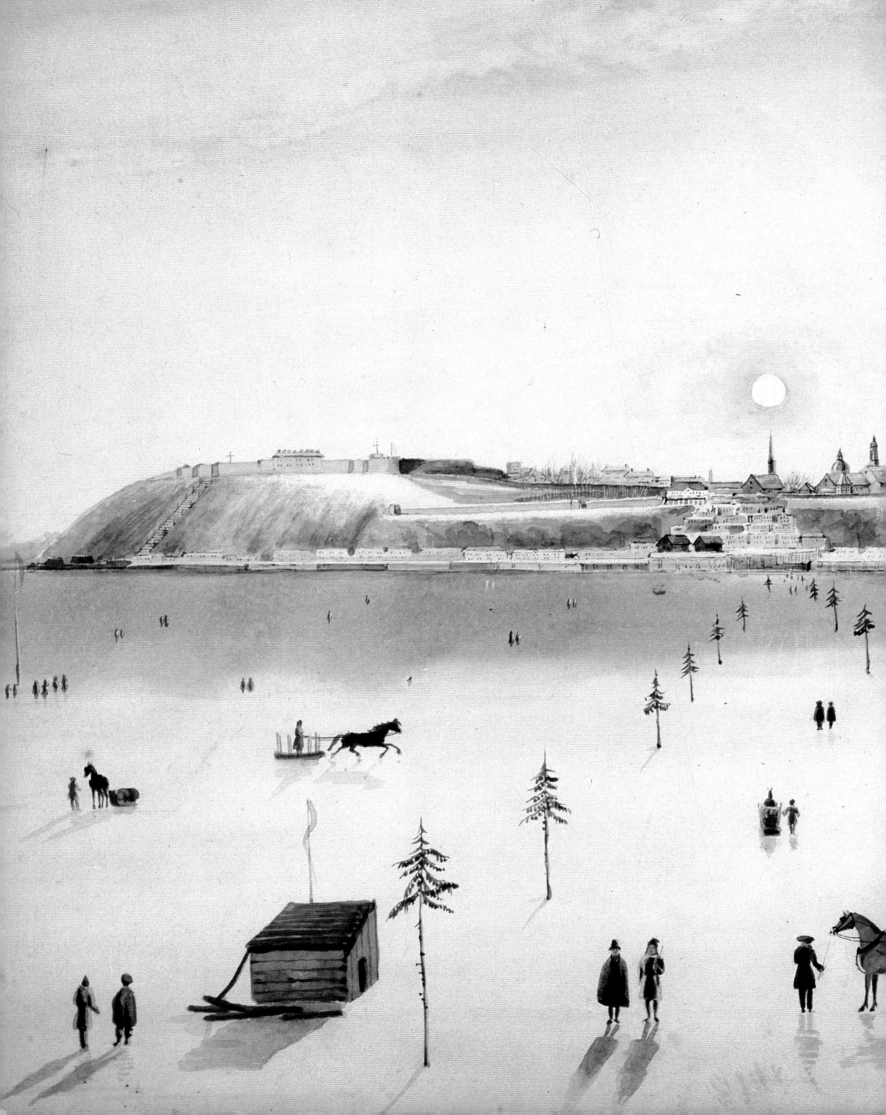

# THE IMAGE OF WINTER
# IN 19TH CENTURY CANADA

# WHEN WINTER WAS KING

## EDWARD CAVELL AND
## DENNIS REID

PUBLISHED BY ALTITUDE PUBLISHING IN ASSOCIATION WITH
THE WHYTE MUSEUM OF THE CANADIAN ROCKIES
BANFF, 1988

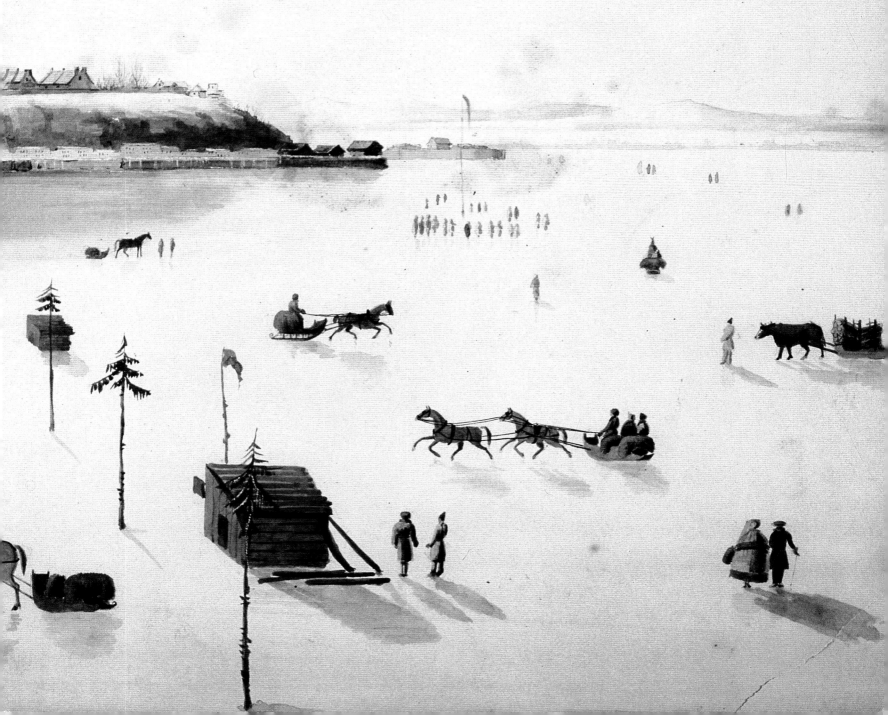

ISBN: 0-919381-35-9 (HARDCOVER)
0-919381-37-5 (PAPERBACK)
0-919381-39-1 (FRENCH PAPERBACK)

We would like to acknowledge the generous financial support of the XV Olympic Winter Games Organizing Committee, the Museum Assistance Programmes of the National Museums of Canada, the Alberta Foundation for the Literary Arts, and the Peter and Catharine Whyte Foundation.
Insurance for this exhibition has been provided by the Department of Communications of the Government of Canada through the Insurance Programme for Travelling Exhibitions.

**Canadian Cataloguing in Publication Data**

Cavell, Edward, 1948-
When winter was king

To accompany the exhibition at the Whyte Museum of
the Canadian Rockies, Banff, Alta., Jan. 26 - Mar. 6, 1988,
and travelling to other galleries.
Co-published by the Whyte Museum of the Canadian Rockies, Banff, Alta.
Issued also in French.
ISBN 0-919381-35-9 (bound). - ISBN 0-919381-37-5 (pbk.)

1. Winter in art – Exhibitions. 2. Painting, Canadian –
Exhibitions. 3. Painting, Modern – 19th century – Canada –
Exhibitions. 4. Photography – Canada – Exhibitions.
I. Reid, Dennis. II. Whyte Museum of the Canadian Rockies
(Banff, Alta.). III. Title.

ND244.C38 1988   759.11'074'011233   C87-095315-X

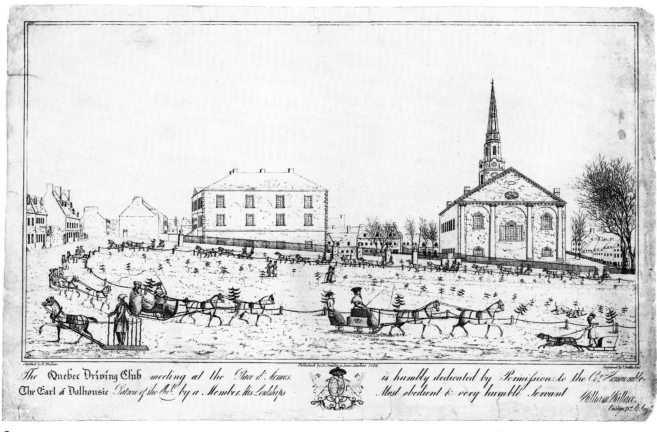

3

ENSIGN WILLIAM WALLACE
**The Quebec Driving Club Meeting at the Place d'Armes**
1826, etching with aquatint (second state), 27.5 × 41.7 cm.
National Archives of Canada, Ottawa (C-62)

2
OVERLEAF:
ANONYMOUS
**Ice Bridge, Quebec**
c.1840, watercolour, 40.6 × 52.4 cm.
National Archives of Canada, Ottawa (C-2062)

# PREFACE

4

ATTRIBUTED TO
PAUL KANE
**Scene in the
North-West – Portrait**
c.1855, oil on canvas,
56.2 × 76.5 cm.
Glenbow Museum, Calgary
(An.55.31.3)

5
OVERLEAF:
LIEUTENANT-COLONEL
JAMES P. COCKBURN
**Cutting Ice for the Summer
at Quebec City**
c.1830, watercolour, 36.7 × 48.9 cm.
National Archives of Canada,
Ottawa (C-40342)

The author of several books on historical photography, most recently *Sometimes A Great Nation: A Photo Album of Canada, 1850-1925*, he has achieved an excellent grasp of Canada's historic photography resources. Equally well-qualified is the exhibition's co-curator Dennis Reid, Curator of Canadian Historical Art at the Art Gallery of Ontario. Mr. Reid is widely recognized as Canada's foremost art historian, and his 1979 publication *Our Own Country Canada: Being an Account of the National Aspirations of the Principal Landscape Artists in Montreal and Toronto 1860-1890* is the seminal work on the subject.

**T**he 1988 Winter Olympics provide a great opportunity to focus world attention on Canada's northern heritage. The Games themselves are surrounded by a panoply of cultural events which allow Canadians to show visitors from around the globe their talents and traditions. *When Winter Was King* has been created in the spirit of this momentous event — an illustration by way of the visual arts of the essential role that winter has played in the tempering of the Canadian identity.

Conceived by Edward Cavell, Curator of Art at the Whyte Museum of the Canadian Rockies, the exhibition draws upon eleven collections across the country for its 76 prints, paintings and photographs created between 1800 and 1900. With a solid background in historical photography, especially in his decade-long position as Curator of Photography at the Whyte Museum, Mr. Cavell is well-suited to head the project.

The Whyte Museum of the Canadian Rockies is proud to have the opportunity to assemble this important exhibition and publication. We extend our thanks to all the loaning institutions, and most particularly to the National Archives of Canada, the Royal Ontario Museum and the McCord Museum who have made the strongest contributions.

An undertaking of this magnitude would not be possible without financial support as well. We would like to thank the Calgary Winter Olympics Organizing Committee, which has contributed to *When Winter Was King* and designated it an "official presentation of the Olympic Art Festival on the occasion of the XV Olympic Winter Games"; the Museum Assistance Programmes of the National Museums of Canada; and the sponsoring agency for my own institution, the Peter and Catharine Whyte Foundation.

Edward J. Hart
Director
Whyte Museum of the Canadian Rockies

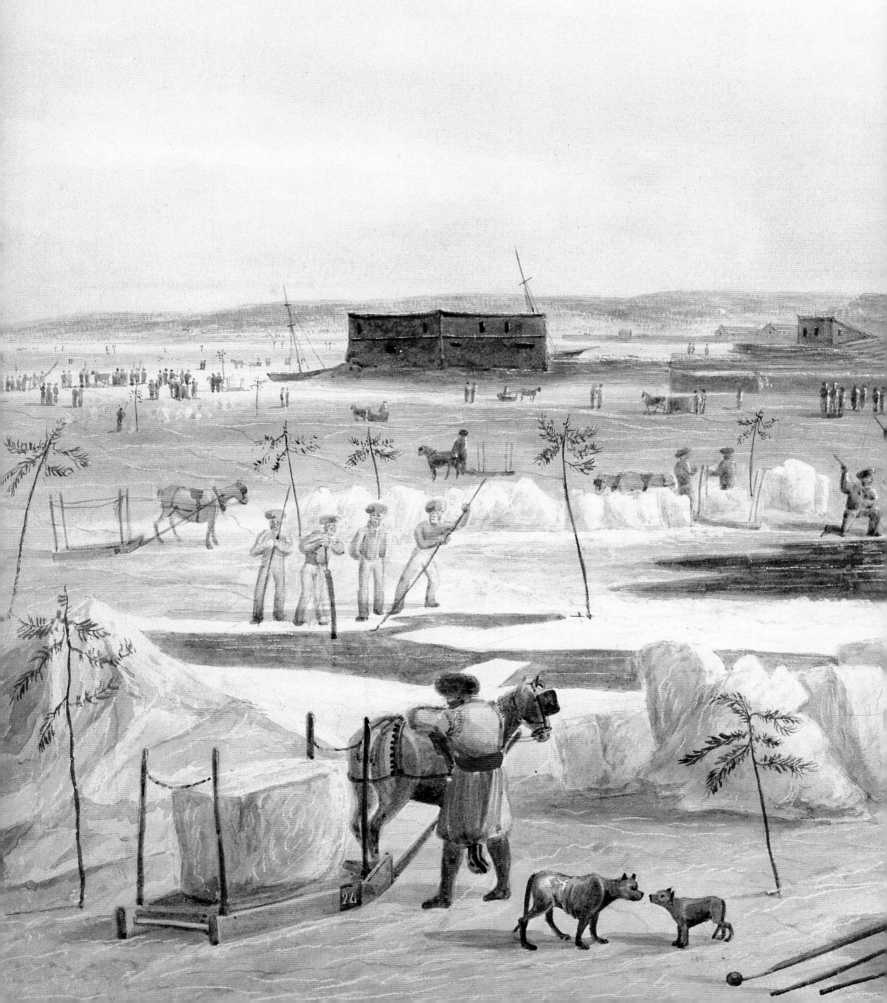

# THE PLATES

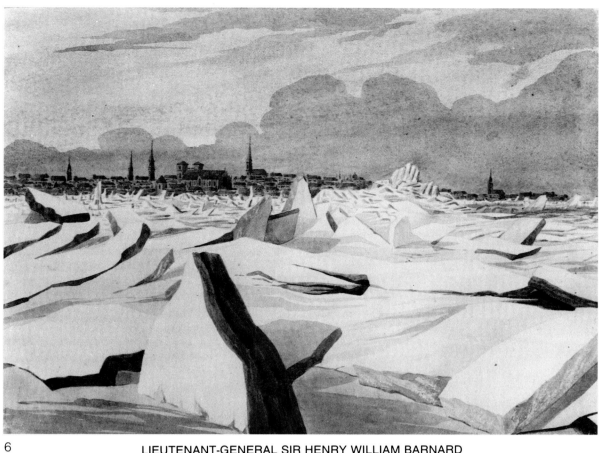

6

LIEUTENANT-GENERAL SIR HENRY WILLIAM BARNARD
**Breaking up of the Ice on the St. Lawrence Opposite Montreal**
1840, watercolour, 20.2 × 27.1 cm.
Royal Ontario Museum, Toronto (949.41.20)

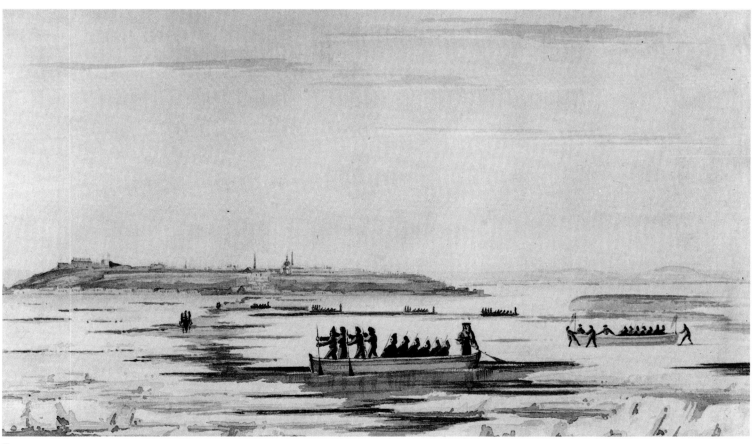

7

LIEUTENANT P.J. BAINBRIGGE
**Expedition on the St. Lawrence River in Winter**
c.1837, watercolour, 20.6 × 35.4 cm.
Royal Ontario Museum, Toronto (960.276.10)

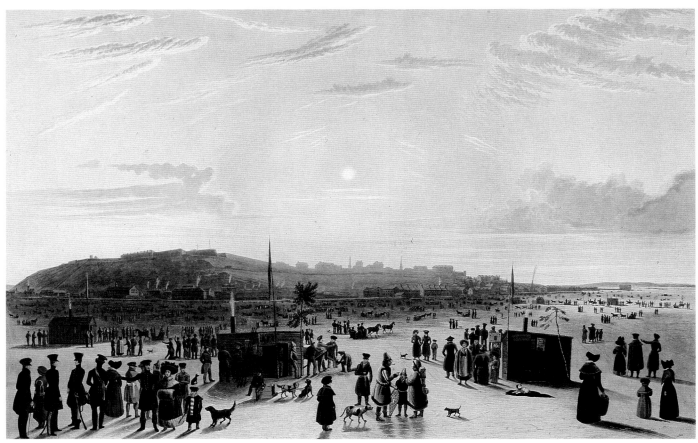

8
LIEUTENANT-COLONEL JAMES P. COCKBURN
**The Ice Pont Formed Between Quebec and Point Lévi**
1833, hand-coloured aquatint, 52 × 71 cm.
National Archives of Canada, Ottawa (C-95618)

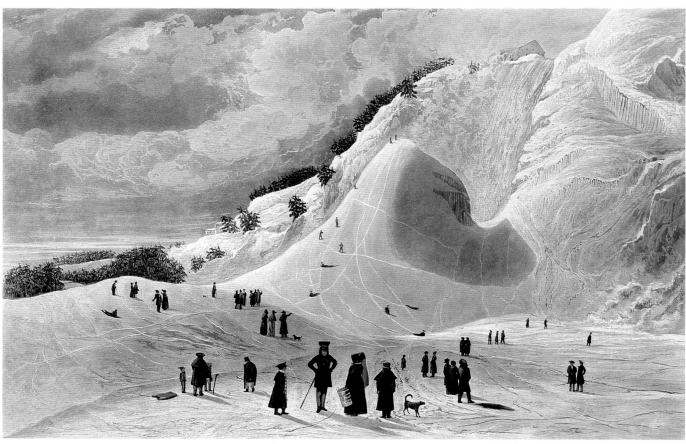

9
LIEUTENANT-COLONEL JAMES P. COCKBURN
**The Cone of Montmorency, as it Appeared in 1829**
1833, hand-coloured aquatint, 51.8 × 70.5 cm.
National Archives of Canada, Ottawa (C-95622)

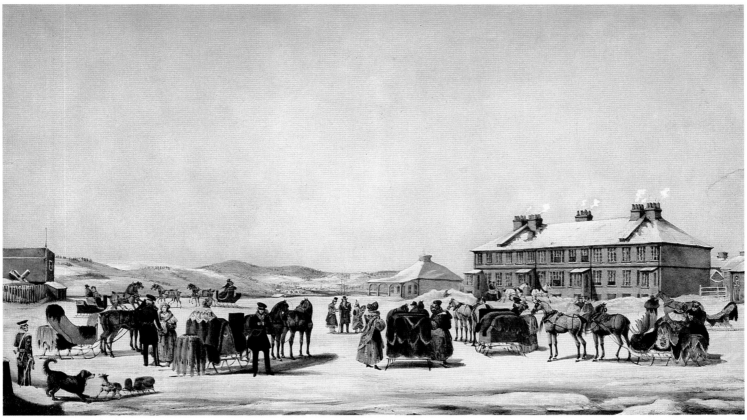

10
LIEUTENANT RICHARD G.A. LEVINGE
**Meeting of the Sleigh Club at the Barracks, . . . Saint John, N.B.**
1838, colour lithograph, 44.8 × 67 cm.
National Archives of Canada, Ottawa (C-6146)

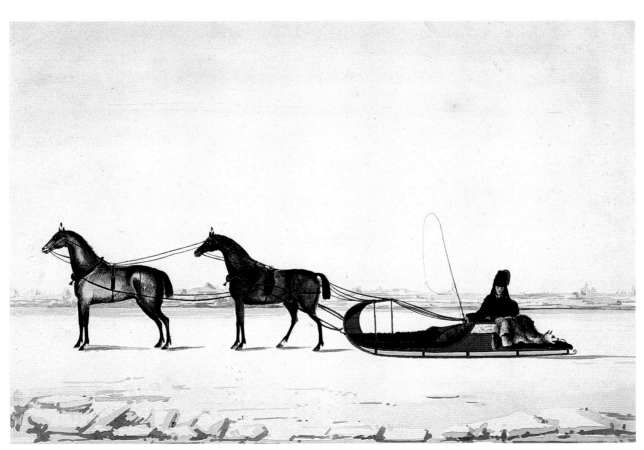

11
ATTRIBUTED TO LIEUTENANT P.J. BAINBRIGGE
**Tandem Sleigh**
c.1835, watercolour, 20.9 × 28.5 cm.
National Archives of Canada, Ottawa (C-4984)

# EDWARD CAVELL
# When Winter Reigned

12

**LIEUTENANT
RICHARD G.A. LEVINGE
Indians Stalking Cariboo**
c.1837, watercolour, 24.3 × 39.2 cm.
McCord Museum of Canadian History,
McGill University, Montreal
(M982.531.4)

For most of us winter has become a rather persistent annoyance that we grudgingly accept but somehow think of as an undeserved plague visited upon us in retribution for an unintended sin. Deep down inside we *know* that if all were right with the world Canada would have the climate of California (and the economy of Japan). Resigned, we scrape the windshield, suffer the snow-logged traffic, hunch our shoulders up to our ears and fantasize about snow white beaches in the southern sun. Some of us, clad in polypropelene armour and bearing down-filled shields, attack the Frost King in weekend sieges, tentative entries into the winter reality, bound for enjoyment but ready to retreat to the cottage or lodge if the season choose to play its adversarial role. At first invigorating, the cold challenges us; and if we trespass a little too far, it reminds us of our fragility. Waiting at an exposed bus stop, stranded on a ski lift or halfway to the corner store, we find ourselves too far from a warm haven; it's a bit too cold and our exposed fleshy parts tingle warm with frostbite. Our primal fear of winter takes over. An instant drama unfolds. It's "seek shelter, or die." Fortunately the convenience store is only a block away, the bus comes or the lift starts, our ability to withstand the cold is better than we first thought – we are saved once more – but we have been touched by winter's icy breath.

Winter seems too obvious a Canadian subject: an inescapable reality that affects all of the country, it even snows in Vancouver! Winter has identified us since Voltaire dismissed Canada as a "a few arpents of snow" and a wag described the weather as "nine months of winter and three months of poor sledding." Our history has happily disproven the gloomy assessment of Canada made by Frances Brooke's heroine in the first Canadian novel *The History of Emily Montague* written in 1794:

*I no longer wonder the elegant arts are unknown here; the rigour of the climate suspends the very powers of the understanding; what then must become of those of the imagination? Those who expect to see "A new Athens rising near the pole" will find themselves extremely disappointed. Genius will never mount high, where the faculties of the mind are benumbed half the year.*[1]

Winter shapes our history, establishes our customs, guides our architecture, and influences our art and literature. It's been everything to Canada except, surprisingly, a popular subject for study. Few critical essays, theses or publications consider the subject, particularly in English.

The first realization which the research for this publication supplied was that we were in the intimidating position of breaking new ground. Further research, guided by a few contemporary articles and a raft of vintage accounts, indicated two things: most of my preconceptions were wrong, and the subject could quickly become too big to handle in a short publication. To solve the second problem we elected to limit our evidence.

Resisting all temptations to the contrary, we limited the topic to the 19th century. The emphasis is on the visual arts, supplemented by a few written resources as context for the art works. The materials reflect a demographic bias towards southern and central Canada, but they accurately reflect the development of Canada and the urban focus of the visual arts. The arctic may seem an obvious omission but we considered it a more extreme experience and beyond the scope the this work. We included western exploration material as a major influence in 19th century Canada.

Looking at the Canadian experience of winter in the 19th century has constantly surprised us. Every statement was counterpointed by a contradictory remark, yet certain consistencies emerged. I had imagined 19th century Canada went into some sort of cabin-fevered, shivering hibernation. Wrong! Anna Brownell Jameson just after her arrival in Toronto in the winter of 1836:

*Now is the time for visiting, for sleighing excursions, for all intercourse of business and friendship, for balls in town, and dances in farm-houses, and courtships and marriages, and prayer-meetings and assignation of all sorts. In summer, the heat and mosquitoes render travelling disagreeable at best; in spring the roads are absolutely impassable; in autumn there is too much agriculture occupation; but in winter the forests are pervious; the settlers in the woods drive into towns, supply themselves with stores and clothing, and fresh meat, the latter a luxury which they can seldom obtain in summer.* [2]

Winter was a sportsmen's paradise, supplying both leisure time and flat, firm surfaces to play on. The game animals were in their prime (and in the snow, at a disadvantage). For the British Garrison Officers and social elite the Canadian winter supplied a colourful and exotic fascination – the only cold colony in a basically tropical Empire. For the farmer winter was a time of rest or opportunity to earn essential additional cash by lumbering or trapping.

Winter can be devastatingly cold and the foul weather a real danger if unprepared, but it is – and was – the exception. The sun did shine and the still air was often quite mild . Most of the newcomers to Canada in the 19th century came from England and western Europe where the climate was relatively moderate, the snowfall minimal. The first encounters with a continental climate where temperatures can easily range from +35˚ C to −40˚ C could be brutal. John Lambert, who travelled in

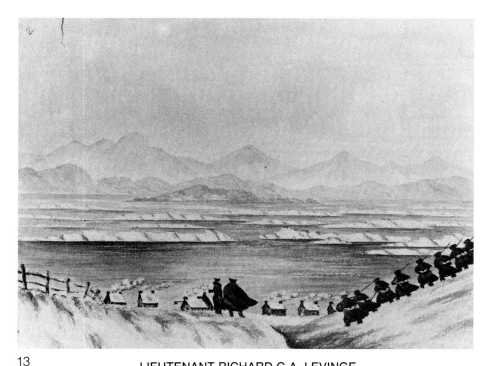

13

LIEUTENANT RICHARD G.A. LEVINGE
**St. Lawrence River in Winter;**
**the 43rd Regiment Marching to Canada from New Brunswick**
1837, watercolour, 20.3 x 26.4 cm.
National Archives of Canada, Ottawa (C-5207)

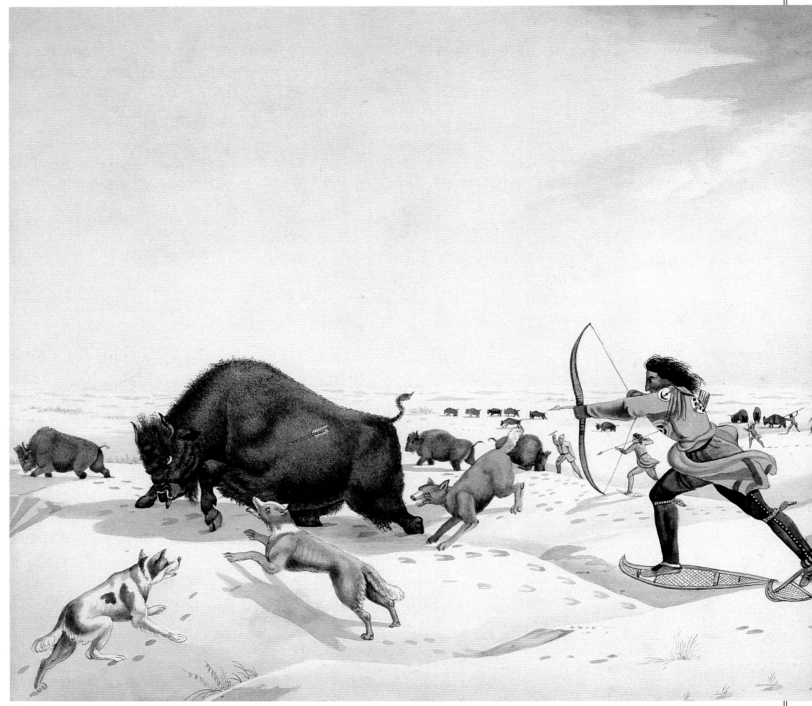

14

PETER RINDISBACHER
**The Dogs Discover
a Herd of Buffalo . . .**
c.1825, watercolour, pen and ink,
24.1 × 43.7 cm.
National Archives of Canada,
Ottawa (C-114462)

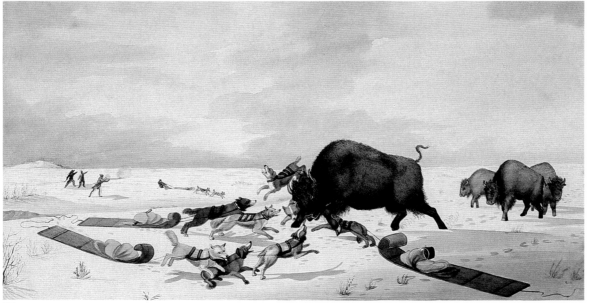

15

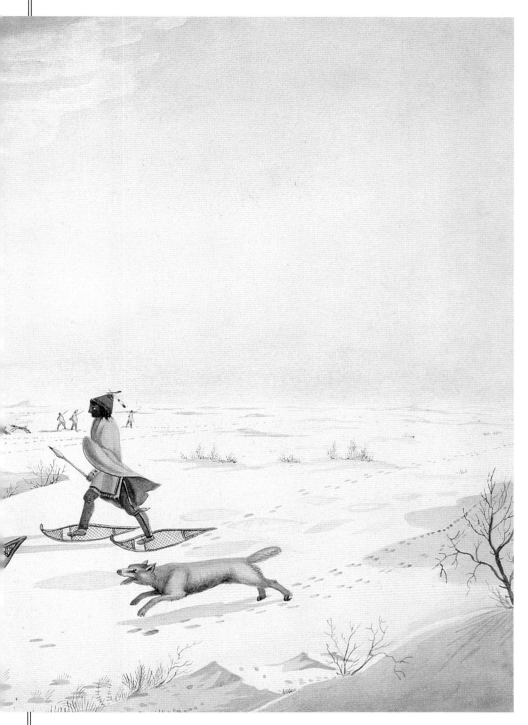

PETER RINDISBACHER
**Indian Hunters
Pursuing the Buffalo
Early in Spring . . .**
c.1825, watercolour, pen and ink,
23.5 × 40.4 cm.
National Archives of Canada,
Ottawa (C-114467)

*I could almost wish myself a dormouse, or a she-bear, to sleep away the rest of this cold, cold winter, and wake only with the first green leaves, the first warm breath of the summer wind. I shiver through the day and through the night... the cold is at this time so intense, that the ink freezes while I write, and my fingers stiffen round the pen; a glass of water by my bed-side, within a few feet of the hearth (heaped with logs of oak and maple kept burning all night long), is a solid mass of ice in the morning.*[4]

Period writing contains many vivid accounts of suffering through the extremes of the winter climate, cold wilderness camps, or losing one's way in in a blizzard or white-out. Despite this, one idea is constantly repeated, winter was the preferred season, with health, the ease of transportation and sporting amusements most cited as the reasons.

Turn-of-the-century roads were few and shockingly rough, dusty, circuitous and often boggy. Rivers were transportation arteries for the resource industries, but before bridges were built, they were often barriers to land travel.

When the freeze-up of the St. Lawrence closed the ports, ending foreign trade for the season, emphasis changed to the domestic. The frozen river became a bridge, a playground, a crystalline freeway connecting cities and neighbours by lightning-fast sleighs. Hugh Gray, author of *Letters from Canada*, published in 1809:

Canada between 1806 and 1808, comments:

*The people of Great Britain suffer more from the cold than the people of Canada; or at least they are more exposed to it; for they seldom make any material alteration in their dress, either summer or winter; and with their open fireplaces, they are burning on one side, and freezing on the other. This, however, hardens the constitution of an Englishman.!!*[3]

We shouldn't minimize the reality of the Canadian winter. Again Anna Brownell Jameson in 1836:

*For the distance of eight miles, you see an immense sheet of ice, as smooth as a mirror. Thousands of people crowd upon it everyday, and booths are erected for their entertainment. In one quarter, you see numbers of people enjoying the amusement of skating; in another you see carioles driving in different directions; for the ice is so strong, that horses go on it with the greatest safety. Sometimes you see cariole races; they go over the ice with great swiftness. In short, when the*

*pont*, takes *(as they term it)*, it occasions a kind of jubilee in Quebec.[5]

Connecting Quebec City to the south shore of the St. Lawrence and ending the isolation of the island of Montreal, the *pont* or ice bridge permitted farm goods, firewood and provisions of all kinds easy access to the cities, eliminating the necessity of trans-shipping goods. The ice bridge, which was used by the railways as well, remained essential for Montreal until the completion of the Victoria Bridge in 1859, and for Quebec City until 1917 when a bridge was completed across the St. Lawrence.

Sleighing was the most popular pastime during the first half of the 19th century for both officers and their "muffins" (the term garrison officers popularly used for local young women) and the habitants. Disputes as vocal as those between drivers of BMWs and Mack trucks arose over the effect on the roads of the basic low-built working sleds used by the Canadians. Frederic Tolfrey in *Colburn's New Monthly Magazine*:

*The floor of the vehicle . . . being so near the surface over which it passes, the loose snow is driven up before it in heaps, and the hillocks so formed are termed by the natives* cahots. . . . *Of all the afflictions under Heaven, the driving over these dislocating unevenesses is beyond compare the greatest; the undulatory motion caused by these frozen national nuisances can be compared to nothing but the pitching of a badly-steered ship in the Bay of Biscay against a head-wind, with the additional misery of being mercilessly bumped and shaken to the excruciating pitch of loosening every tooth in your head. . . . All my countrymen, more especially those who had imbibed a taste for coaching at home, invariably adopted the high runner; and if the legislature were to enact a law prohibiting the use of the traineau and low sledge throughout the country, much inconvenience would be avoided, and considerable good would result to every class in the community.*[6]

Speeding along in a high-runnered, crimson sleigh, decked with fine furs and regimental colours, horses in tandem, a muffin at his side, the English officer could well imagine Quebec the "pleasantest of all garrisons." There were picnic trips to Montmorency Falls with its spectacular ice cone formed by the cold and the spray. One could wander inside chambers of ice sculptures carved into the cone, or slide down the outside. A local lad could be hired to demonstrate the phenomenal speeds achieved by a toboggan launched from the top, for those too timid to risk it.

To the amusement of the habitants the high sleighs were quite unstable, and wandering off the hard-packed road usually caused a chilly sprawl in the snow. Travelling on the frozen rivers was "remarkably pleasant, the draft to the horse is nothing, in fact he has little else to do than to get out of the way of the carriage." Other dangers accompanied river travel, however. Hugh Gray recorded:

*When horses go on the lake, they always have, round their necks, rope with a running noose . . . The moment the ice breaks, and the horses sink into the water, the driver, and those in the sleigh,*

CORNELIUS KRIEGHOFF
**The Blizzard**
1860, oil on canvas, 33 × 45.7 cm.
McCord Museum
of Canadian History, McGill University,
Montreal (M967.100.21)

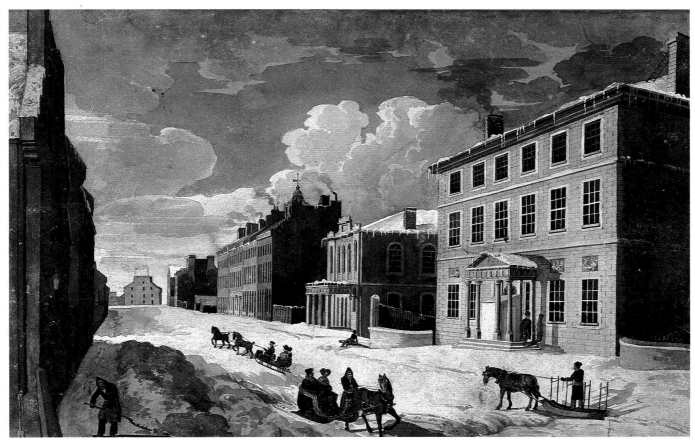

17

ROBERT SPROULE
**Saint James Street, Montreal**
1829-30, watercolour, 24.1 × 35.3 cm.
McCord Museum of Canadian History, McGill University, Montreal (M300)

18

LIEUTENANT-COLONEL JAMES P. COCKBURN
**Quebec from Château Saint-Louis**
c.1830, watercolour, 15.2 × 23.8 cm.
National Archives of Canada, Ottawa (C-12476)

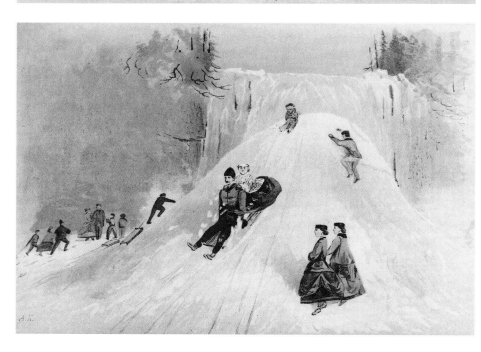

*get out, and catching hold of the ropes, pull them with all their force, which, in a very few seconds, strangles the horses; and no sooner does this happen than they rise in the water, float on one side, and drawn out on strong ice, the noose of the rope is loosened, and respiration recommences; in a few minutes the horses are on their feet, and much alive as ever.*[7]

The ease of travelling on snow brought the urban dweller into the ever-surrounding wilderness, providing us with some of the more reflective accounts of 19th century life. Anna Brownell Jameson:

*Nature is the ghost of herself, and trails a spectral pall; I always feel a kind of pity – a touch of melancholy – at this season I have wandered among withered shrubs and buried flower-beds; but here, in the wilderness, where Nature is wholly independent of art she does not die, nor yet mourn; she lies down to rest on the bosom of winter, and the aged one folds her in his robe of ermine and jewels, and rocks her with his hurricanes, and hushes her to sleep. How still it was! how calm, how vast the glittering white waste and the dark purple forecasts!*[8]

Above all, the residents responded to winter's startling beauty. The pristine snow-covered landscape stirred the soul.

The different perception of winter in Canada, which Anna Brownell Jameson points out in her comment, rings true throughout our literature and the visual arts. In Canada, winter is perceived as the sleep before rebirth and not analogous to death. It was – and is – considered as a season of relaxation and amusement rather than depression.

Other popular outdoor activities included curling, skating, tobogganing, ice boating and hockey. Skiing is a later development introduced by the Governor-General Lord Frederic Hamilton in 1887, and not popular until after 1900. The popularity of these pastimes evolved both with the growth

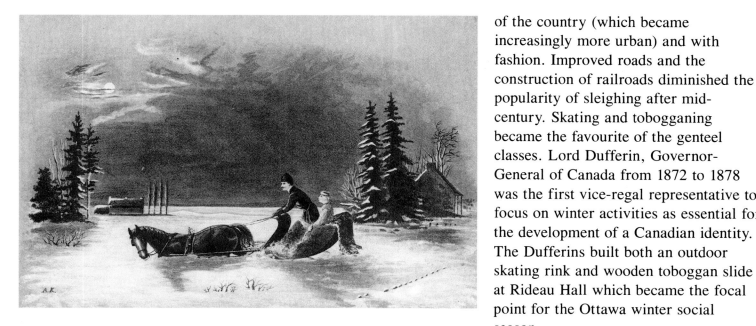

of the country (which became increasingly more urban) and with fashion. Improved roads and the construction of railroads diminished the popularity of sleighing after mid-century. Skating and tobogganing became the favourite of the genteel classes. Lord Dufferin, Governor-General of Canada from 1872 to 1878 was the first vice-regal representative to focus on winter activities as essential for the development of a Canadian identity. The Dufferins built both an outdoor skating rink and wooden toboggan slide at Rideau Hall which became the focal point for the Ottawa winter social season.

The introduction of covered skating rinks, the first in the world being built in Quebec City in 1852, revolutionized the social life of the colony. From *The Cornhill Magazine*, 1862:

*These are the skating clubs, where morning, afternoon, and evening, ladies and gentlemen may be seen combining the gaiety and evolutions of a ball-room with the outdoor skill and activity of the most accomplished performers on the Serpentine. The officers not unfrequently enliven the scene with the music of a military band, and the beautifully-executed figures go merrily on. Under cover, and in a limited space, figure-skating, of course, becomes the fashion, and tyros, male and female, may be seen at peep of day hurrying to the rink, hoping that wriggles and contortions which precede the acquirement of that ease and apparent absence of force, which mark a finished skater, may escape the observation of more experienced connoisseurs.*[9]

ATTRIBUTED TO ALICIA KILLALY
**A Picnic to Montmorenci**
1868, set of six chromo-lithographs, each 32.6 × 41.1 cm.
Royal Ontario Museum, Toronto (960.276.92-97)

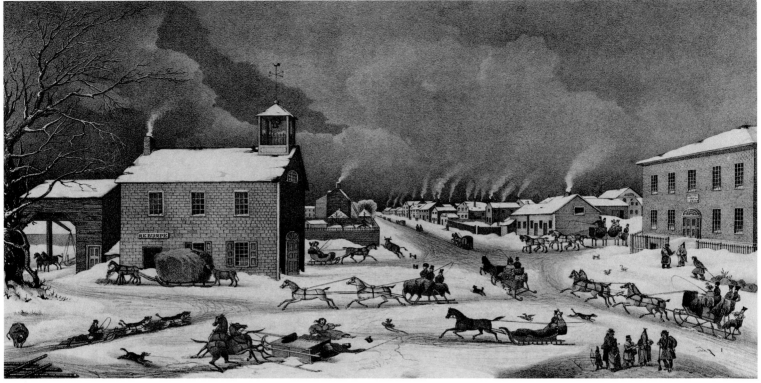

LIEUTENANT
JOHN CAMPBELL
**New Brunswick
Fashionables!!!**
1834, lithograph,
48.7 × 64.3 cm.
McCord Museum of
Canadian History, McGill University,
Montreal (M19903)

The fancy dress skating carnival became the high-point of the social season, the Victoria Rink in Montreal became the focus. This rink was also the birthplace of our national sport when the first game of hockey as we know it was played indoors in 1875. Evolving from forms of shinny, hockey in its earliest manifestations was more free ranging: "the number of players was so flexible that it was restricted only by the quantity that turned up to play and also by the thickness of the ice." It had become more regularized by the time it moved indoors. It had also become very popular, much to the disgust of the patrons of the rink who lost ice time. The directors were accused of having "hockey on the brain."

Developed from the Indians, toboganning was unique to North America and, with ice boating, was as fast as a person could go in the 19th century world. The sport gained favour in the latter half of the century. Besides the natural hills, wooden slides appeared throughout the east and remained popular till well into the 20th century. Again *The Cornhill Magazine*:

*Tobogining. . . . is suggestive of
nothing but romps and tumbles, and*
*"muffining" under difficulties. . . . Let
the reader fancy himself at the top of
Fort Henry, the day fine and frosty, his
hair and whiskers white, as with a
respectable old age, and each point of
his moustache the base of an incipient
iceberg. The hill is of the proverbial
steepness of the side of a house, covered
with glistening snow, and below him
stretches a mile or two of ice, some two
feet thick, with patches of snow drifted
over its level black surface. He and his
companions are provided with
toboggins, and a half-a-dozen ladies are
of the party; for in Canada ladies are
essential accompaniments of merry-
making both indoors and out. . . . The
steersmen of the party provide
themselves with short pointed pieces of
stick, with which they shape their course
down the slippery descent. A gentleman
kneels down at the first toboggan; holds
it carefully to prevent a false start; tucks
in the lateral superfluities of dress
belonging to the lady, who has seated
herself in the prow of his ship with her
feet pressing against the turned-up end;
cautiously seats himself on the floor
behind her, sticks in hand – friendly
shove, and they are off!*[10]

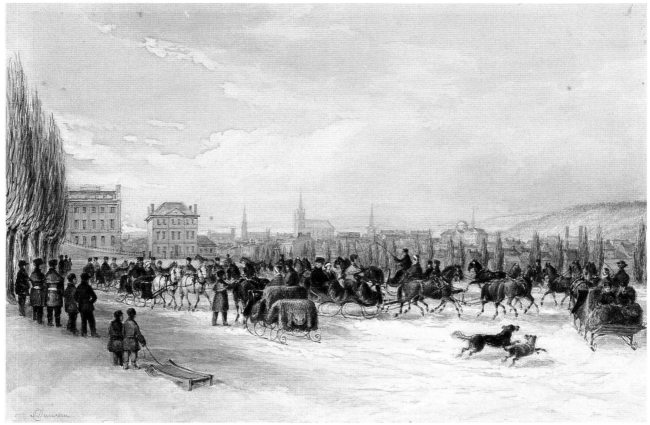

21

JAMES DUNCAN
**The Quebec Tandem Club, Champ-de-Mars, Montreal**
c. 1840, watercolour, 32.2 × 47 cm.
Royal Ontario Museum, Toronto (953.186.1)

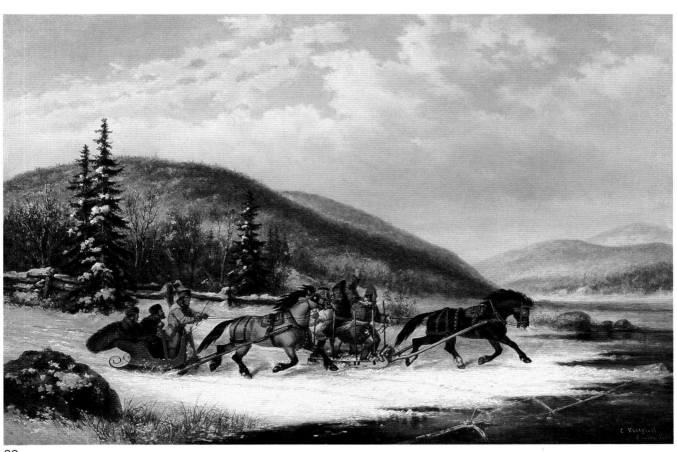

22

CORNELIUS KRIEGHOFF
**Sleigh Race Across the Ice**
1861, oil on canvas, 35.5 × 53.4 cm.
Montreal Museum of Fine Arts, bequest of Lady Allan, 1957 (957.1177)

Snowshoeing, like tobogganing, was a traditional native practice. Clubs organized in the 1840s, and by the 1870s the sport reached popularity bordering on fad. Touting the morality of health and exercise under the philosophy of muscular Christianity *(mens sana in corpore sana)*, hundreds of snowshoers embarked on ten-mile tramps through the woods. Dressed in white blanket coats, tight leggings, tuques and colourful sashes, they looked, according to Lady Dufferin, "very picturesque and very Canadian." In 1873 the first snowshoe torchlight procession up Montreal's Mount Royal was given in honour of Lord and Lady Dufferin. The "fiery serpent" would become a winter carnival tradition.

Almost all of our traditional leisure activities have evolved from necessities developed for winter survival. It's important to remember the realities of winter work in the face of the frivolity of winter sports. Artist Paul Kane recounts his experience during a trip in the west in 1846-48:

*"This day I suffered a great deal; my feet were so severely cut by the frozen strings of my snow-shoes, that I left a track of blood behind me on the snow at every step. . . . I found I had what voyageurs call* mal de racquet. *This complaint attacks those who are unaccustomed to the use of snow-shoes, if they walk far on them at first. It is felt at the instep. I do not know how to convey an idea of the intense pain, except by saying that it feels as if the bones were broken, and the rough edges were grinding against each other at every motion. . . . The mal de racquet tortured me at every step; the soles of my feet were terribly cut and wounded from ice, which formed inside of my stockings as much as an eighth of an inch thick every day, occasioned by the freezing of the perspiration. It breaks in small pieces, and is like so much sharp gravel in shoes."*[11]

The sportsman had to endure less painful experiences, hurting his ego more than his body. *The Cornhill Magazine*:

*There he lies sprawling and struggling on his stomach, as helpless as a sheep on its back in a ditch. The toes of his shoes have run into the snow; one, perhaps, has come off, and down that leg goes, as far as is consistent with his formation as a bifurcated animal. A more pitiable condition cannot be imagined; and yet, strange to say, it is one more provocative of mirth than any it has been our misfortune to laugh at, when weeping, perhaps, would have been considered in better taste.*[12]

The Montreal Winter Carnival, held between 1883-89, was started by the snowshoe clubs to promote winter sports. With its splendid ice palaces (one was over 110 feet high) the carnival epitomized the celebration of winter in Canada. As a finale the snowshoers, in traditional dress, paraded through the city streets before performing a mock attack on the glowing ice palace in the midst of a pyrotechnic display. The

23

BURLAND LITHOGRAPHIC COMPANY
**Ice Palace, Montreal Carnival**
1889, colour lithograph, 46.9 × 63.5 cm.
McCord Museum of Canadian History, McGill University, Montreal (M5878)

**NOTES**

1. Frances Brooke, *The History of Emily Montague*, New Canadian Library edition: Toronto McClelland and Stewart 1961, pp. 90-91

2. Anna Brownell Jameson, *Winter Studies and Summer Rambles in Canada*, London 1838, pp. 25-26.

3. John Lambert, *Travels through Lower Canada and the United States of America in the Year 1806, 1807 and 1808*, Vol. 1, London, Richard Phillips 1810, p. 122.

4. Jameson, *op. cit.* p. 29.

5. Hugh Gray, *Letters from Canada Written During a Residence there in the Years 1806-1807-1808*, London, Longman, Hurst, et al. 1809, p. 256.

6. Frederic Tolfrey, *A Winter and Summer in Canada*, Colburne's New Monthly Magazine, Vol. 61, p. 386.

7. Gray, *op.cit.* pp. 276-278.

8. Jameson, *op.cit.*, pp. 42-43.

9. *The Cornhill Magazine*, Vol. V, January-June, London 1862, p. 213.

10. *Ibid.*

11. Paul Kane, *Wanderings of an Artist Among the Indians of North America*, London, Longman, Brown et al., 1859 pp. 352-358.

12. *The Cornhill Magazine, op. cit.*, p. 214.

13. Thomas Conant, *Life in Canada*, Toronto, William Briggs, 1903 pp. 258-260.

consummate combination of myth, fantasy and the zealous enjoyment of invigorating winter!

But then I've digressed. The enthusiasm of Canada's winter advocates has snared me. My mistake is not particularly modern. After the turn of the century the chilly amusements were falling from favour. The nation had become image-conscious and winter evangelism turned to denial. Thomas Conant, *Life In Canada*, 1903:

*Now, this article was all about snowshoers, toboggans, toques and ice-palaces, and would lead the stranger to infer that Canada is a land of snow and ice. The premises are false, so far as Ontario is concerned, and no one would think of building a snow-palace in Toronto, because during the days required for its construction a thaw would probably occur, which would demolish the ice-palace faster than it was ever built. Out of two millions in Ontario, I think I am safe in asserting that not more than 5,000 of its inhabitants ever stepped upon a snowshoe. As to toques and toboggans, they are scarcely thought of. . . .*

*We are glad to have our Governor-General and his staff at Ottawa enjoy themselves tobogganing down the artificially-made slide of boards and scantling near Rideau-Hall, and no doubt the ladies do look attractive by the glare of torches, dressed in blanket cloaks, toques, fezzes, and the like. Such peculiarities, however, do not add to the wealth of our country.* [13]

Sheltered from the storms in centrally-heated, insulated urban society, Canadians changed. Winter became an inconvenience, definitely bad for business. This attitude has stayed with us and, if anything, we've grown more distant from the forces that moulded the lives of 19th century Canadians. We endure winter but watch nightly on television imagery from the perpetual summer of Pacific America.

We cannot live in this climate and not be deeply affected by it. Winter becomes a collection of small, intense perceptions as graphic as the instant foolish desperation of a youngster with tongue bounded to cold metal. Well-wrapped, we pass through a silent world, the screaking of cornstarch snow underfoot. Crystal-clear light shatters on every surface and glints like minute prisms in the snow. We are warmed by intensely yellow light spilling from a window into the deep cyan velvet of the evening and breaths taken at − 30° C are sharp and tentative in the suspicion that a deep lungful would freeze our very souls. Winter is a memory, a good story – the summation of challenges and observations that fill our lives – and always better in the telling.

By sharing the experience of the past through these paintings, photographs and prints, we can see that our realization of winter is not limited to the moment but is part of the understanding that Winter is still King.

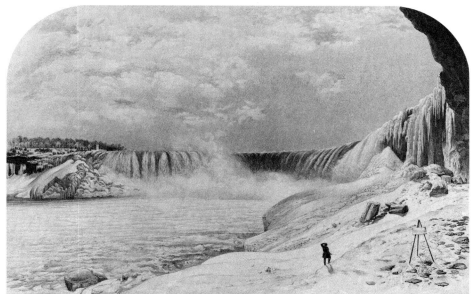

24

**F.W. LOCK**
**Niagara Falls, Winter View of Horseshoe Falls**
**Taken from the Canadian Side, February 1856**
lithograph, 65.5 × 89.5 cm.
National Archives of Canada, Ottawa (C-46108)

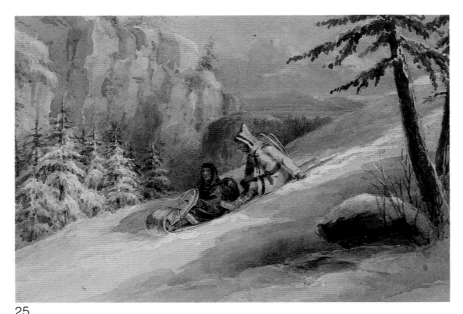

25

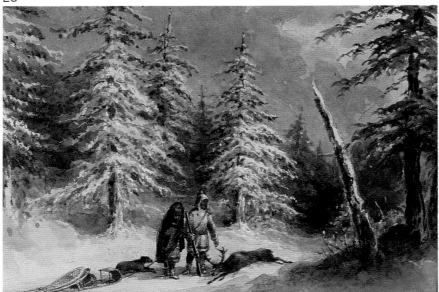

26

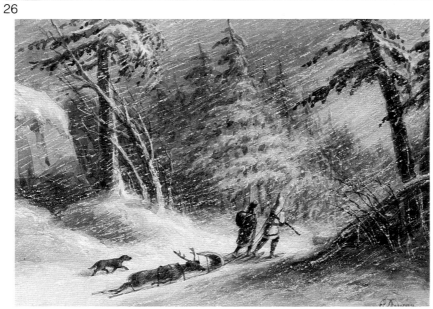

27

JAMES DUNCAN
**Indian Couple Sliding on Toboggan**
**Indian Couple with the Kill**
**Indian Couple Returning Home**
c.1860, watercolours, 17.2 × 24.1 cm.
McCord Museum of Canadian History, McGill University, Montreal
(M20397, M20399, M20400)

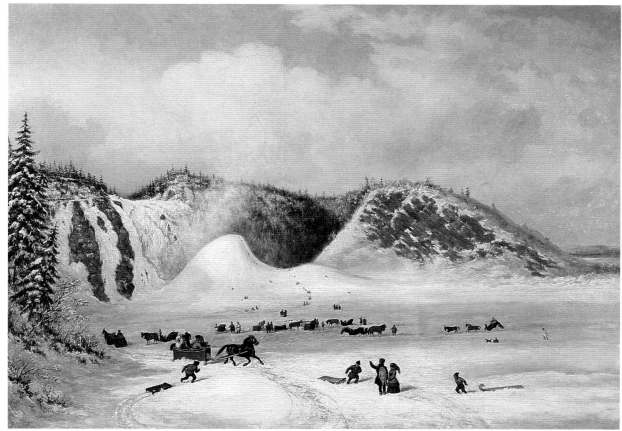

28

**CORNELIUS KRIEGHOFF**
**Montmorency Falls, Winter**
1853, oil on canvas, 46.4 × 64.3 cm.
Montreal Museum of Fine Arts, bequest of Charlotte C. Thomson
in memory of her husband Peter Alfred Thomson, 1963 (963.1439)

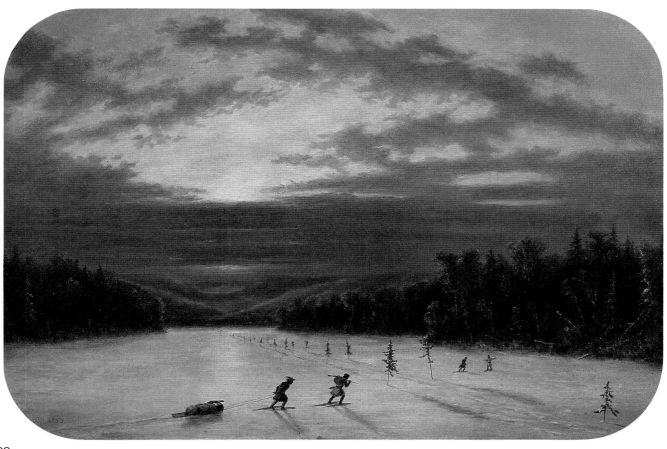

29

**CORNELIUS KRIEGHOFF**
**Tracking the Moose on Lake Famine South of Quebec**
1863, oil on canvas, 35.6 × 53.3 cm.
McCord Museum of Canadian History, McGill University, Montreal (M967.100.60)

# DENNIS REID
# Winter in 19th Century Canadian Painting

30

**WILLIAM EAGAR**
**Tandem Club**
**Assembling in Front of**
**Dalhousie College,**
**Halifax, N.S.**
1839, lithograph, 25.3 × 40 cm.
National Archives of Canada,
Ottawa (C-13362)

Were we to imagine "the typical Canadian painting," it would depict an unpopulated snowy landscape. J.E.H. MacDonald's snow-laden trees, A.Y. Jackson's snow-bound villages, Lawren Harris' commanding snow-peaked Rockies, the perpetual winter of the Arctic pursued by Jackson, Harris, and Fred Varley as a quintessential image of the Canadian experience: these paintings evoke the archetype. Works by many other artists support such a view: for example, Clarence Gagnon, Réné Richard and, more recently, Jean-Paul Lemieux. Even the great black-and-white abstractions Paul Emile Borduas painted in Paris in the 1950s have been related to the snow-swept vastness of Canada. Winter, which we endure for anywhere from five to eight months, is as central to our lives as it is to the artistic view of ourselves. Examination of the evidence, however – the art of our forebears in its time and place – reveals the situation is far from straightforward.

Europeans and their descendants have been making art in what we call Canada since the middle of the seventeenth century, yet not a single painting of snow survives from the whole period of New France. All evidence suggests none were made and, indeed, that there was no interest in painting the Canadian landscape. The first snowy landscape by a native-born Canadian dates to about 1839 – a little oil study on paper of the Montmorency Falls ice cone by the prominent Quebec painter Joseph Légaré. His only other documented winter scene is a more ambitious canvas of the same phenomenon, dated 1850. Légaré, usually credited with being the first Canadian to paint landscape for its own sake, likely derived this practice from British artists, members of the garrison that occupied Quebec following its conquest in 1759. Légaré was responding to a changing clientele that was attracted to images of a sort different from those that had served the French community for almost two centuries.

Two points will help us understand what we find in the short study of winter in nineteenth century Canadian painting that follows. First, art has traditionally been more concerned with ideas – philosophical or ideological concepts – than it has with visual experience. Second, the conception of images derives from the example of other images, not directly from perceived nature. More simply put, art derives from other art, and changes as its function changes.

# DENNIS REID
# The Garrison Artists

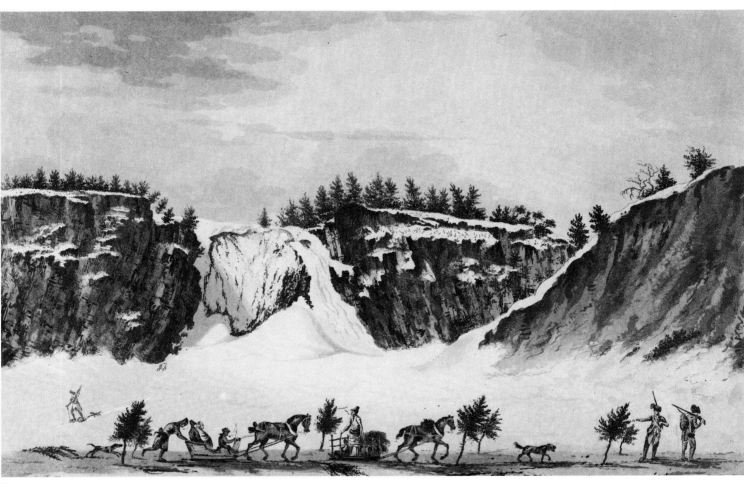

31
**JAMES PEACHEY**
**A Winter View of the**
**Falls of Montmorency,**
**from the Road on**
**the Ice Fronting it**
c.1785, etching with aquatint,
33.9 × 50.5 cm.
National Archives of Canada,
Ottawa (C-13696)

The art of New France was turned almost entirely to the service of the Roman Catholic Church. Virtually all of the paintings of the period that are known today are devotional images or commemorative portraits of clerics, but the coeval art of metropolitan France included still lifes, landscapes, allegorical themes, and images of *fêtes galantes*. New France, forged in the crucible of the Counter Reformation, however, sustained itself in the face of hardship through sacrifice and a rigorously observed faith. The British community that developed after the Treaty of Paris in 1763 was largely Protestant, much more secular, and

preponderantly military. Until close to the mid-nineteenth century the military dominated the social and cultural life of the growing English-speaking population *and* that of the urban French.

32
OVERLEAF:
CORNELIUS KRIEGHOFF
**The Blacksmith's Shop**
1871, oil on canvas, 56.5 × 92.1 cm.
Art Gallery of Ontario, Toronto, gift of
Mrs. J.H. Mitchell in memory of her mother
Margaret Lewis Gooderham, 1951 (50/13)

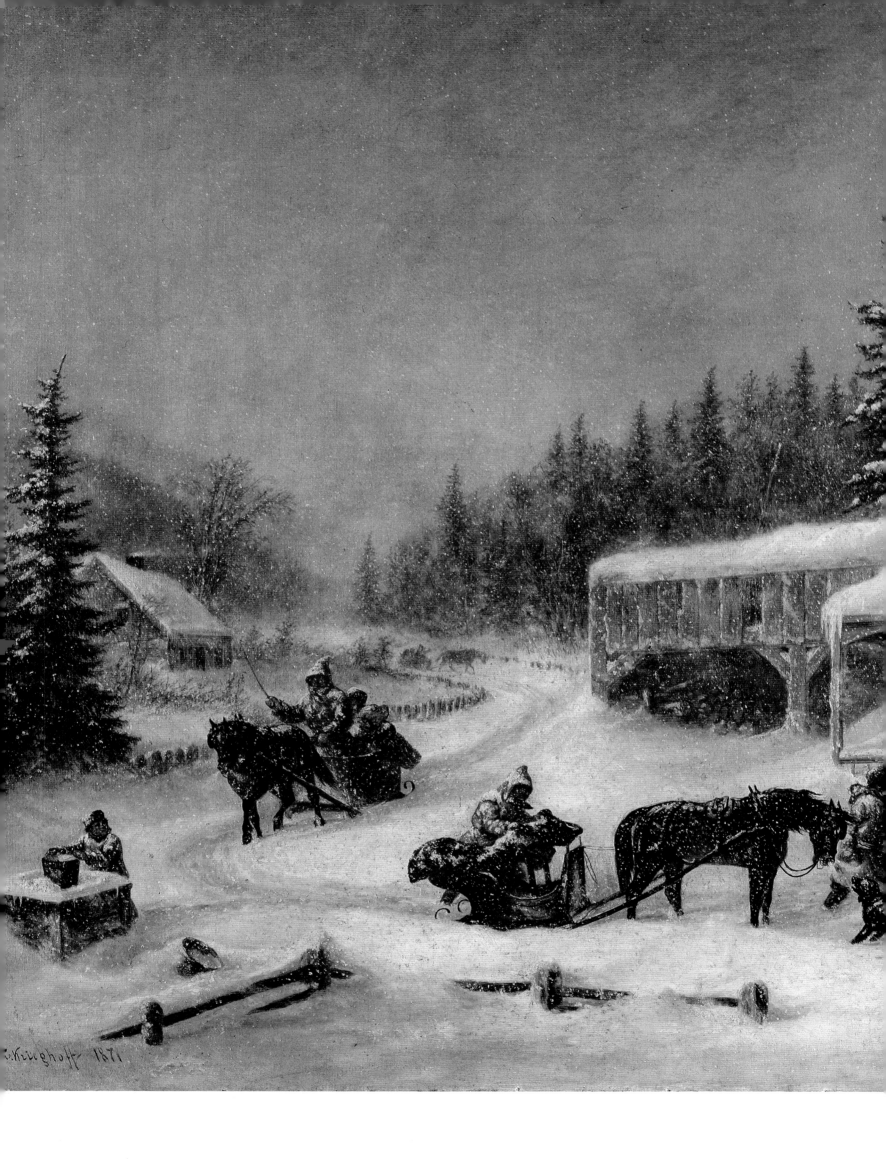

**James Peachey**

British topographer and draughtsman of unknown origin and training who was employed by General Sir Frederick Haldimand, Governor of Quebec, from about 1780 until 1783, at which time he was appointed a deputy provincial surveyor. Returning to London in November 1784, he joined the army in October, 1787, and rose to the rank of captain, serving mainly in America. Died of fever in Martinique, 1797.

Britain's was an imperial army, active in many far-flung corners of the world. Its officers were gentlemen of the upper classes, trained in the practices and expectations of a highly developed and inquisitive intellectual and social life. Their broad experience drew them to the novel and more intense aspects of foreign postings, and their training led them to collect and compose the evidence of their experiences. British imperial government encouraged mobility, particularly among the military, which meant the exotic aspects of a posting were pursued and enjoyed with vigour and urgency, for postings were often short. Almost all British gentlemen, and ladies, by the end of the eighteenth century practised a kind of souvenir sketching, developed from topographical painting (derived ultimately from Dutch landscape models), from a tradition of "estate portraiture" in which country homes were recorded in all their anticipated perfection, and from a heightened delight in travellers' experiences of landscape variety, the rough beauty of ruins or primitive structures, and the charm of foreign customs. Handbooks codified such picturesque qualities. By the onset of the nineteenth century the pursuit of even more profoundly moving experiences of the "sublime," gaping chasms and crashing waterfalls, had become like a religion. This "religion" superseded the Catholic faith in much of the art produced in Canada in the seventy or so years following the British conquest.

Like all religions, the cult of the picturesque became to a remarkable degree institutionalized. "Industrialized" might be a better term, for the printing of views supplied from the outposts of empire centred on a few London shops, the whole business representing a considerable industry. It seems all the serious topographical artists working in this tradition aspired to publish their views in large format etchings, engravings or, a little later, lithographs,

or as illustrations in the travel narratives which constituted the other leg of the industry.

Given the nature of this aspect of English art, we expect to find in it evidence of that novel, and to Englishmen, exotic, phenomenon characteristic of the Canadian winter: snow. Winter scenes hardly begin to approach an incidence relative to the duration of the season (doubtless because sketching in watercolour in sub-zero conditions is difficult), but we are not disappointed. The serious garrison artists have left us winter images that reflect both the changing function of art in a changing Canadian society and the awareness of the artists of one another's work.

The earliest winter scenes I am aware of are James Peachey's watercolour views of the Montmorency ice cone which he took in the spring of 1781. Reproduced in outline etchings, possibly in Quebec (the earliest prints made in Canada, if that be the case), they were also published in London about 1785, and re-issued by the firm of R. Pollard there in 1786 as good-sized aquatints. *A Winter View* (Plate 31) is the most interesting, for Peachey has given us not only a clear view of the great torrent and its impressive cone of ice, but has also described a cabriole, the local passenger sleigh, as well as the more humble sledge of an habitant. We also see the characteristic winter dress of the habitant – blanket coat, *ceinture fleché*, tuque, and pipe – and even a hunter on snowshoes. The manner of marking a tested road across the ice by small evergreens is also evident. The slightly menacing, lounging British soldiers place the exotic scene within the Empire. To maintain the appearance of untouched wilderness, the print omits a small pavilion evident in the original watercolour, a platform cantilevered out over the brink of the falls to offer the most sublime viewing experience. Later views of the ice cone make no such

33

WILLIAM ARMSTRONG
**Frozen Railway Tank at Niagara**
1855, watercolour, 19.7 × 20.8 cm.
Royal Ontario Museum, Toronto (965.138.2)

34

WILLIAM H.E. NAPIER
**King's Port, Tadousac**
1842?, watercolour, 13.9 × 21.6 cm.
McCord Museum of Canadian History, McGill University, Montreal (M458)

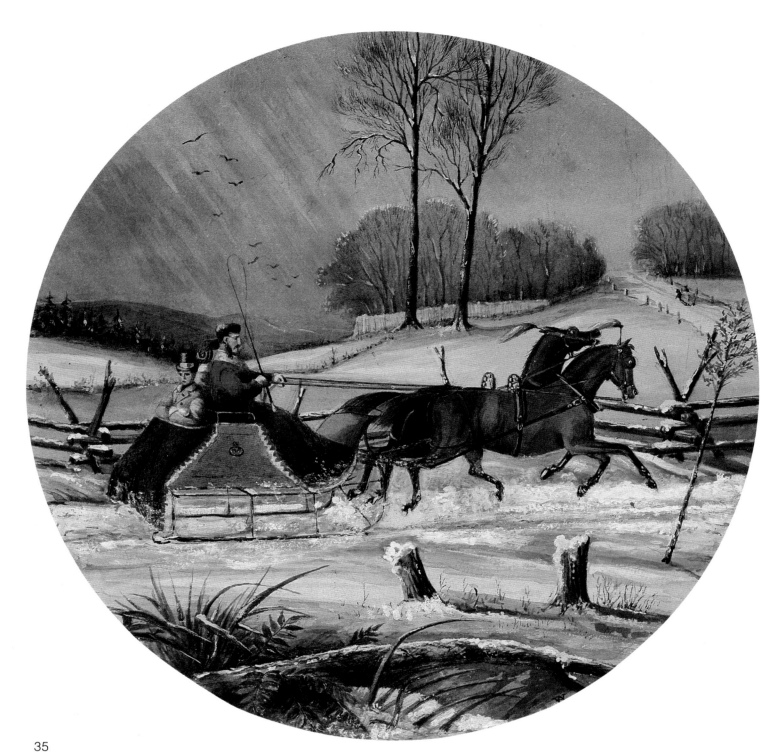

35

**WILLIAM ARMSTRONG**
**Côte de Neiges Road, Winter**
1856, watercolour, 25.2 cm. diam.
National Archives of Canada, Ottawa (C-70850)

### Ensign William Wallace

He was stationed at Quebec with the 74th Light Infantry, 1824-30. Nothing more is now known of him.

### Lieutenant John Campbell

Born 1807 into a military family, he entered the army as ensign in the 38th Regiment in 1821, at that time commanded by his father, Sir Archibald Campbell (1769-1843). Following service in India and Burma, he was in Fredericton, N.B., 1831-37, as aide-de-camp to his father, who was then Lieutenant-Governor of New Brunswick. He later served as Lieutenant-Colonel of the 38th in the Mediterranean, Caribbean, and in Nova Scotia. He succeeded to the baronetcy in 1843, and was killed in the Crimea in 1855, by which time he had achieved the rank of brigadier-general.

### Lieutenant-Colonel James Pattison Cockburn

Born 1779 into a military family at New York, where his father was posted. He studied drawing under Paul Sandby while an officer-cadet at the Royal Military Academy, Woolwich, 1793-95. Stationed at Quebec 1826-32 with the rank of lieutenant-colonel, he served as Regimental Major of the 60th Regiment of Royal Artillery, and commander of the Royal Artillery in Canada. The most serious of amateur topographers, he published four sets of large aquatint views, and numerous illustrated travel books while pursuing a highly successful military career. He achieved the rank of major-general before retiring in 1846, and died at Woolwich the following year.

concessions as it became a focus for winter socializing for the inhabitants of Quebec.

Other important winter entertainments were the driving clubs formed by officers and their friends as a way of taking the air while promenading their handsome light sleighs and equally handsome teams of horses harnessed in tandem. An early view of the Quebec club parading in Place d'Armes, drawn by Ensign William Wallace of the 71st Light Infantry, was engraved and published by D. Smillie & Sons of Quebec in 1826 (Plate 3). Dedicated to the Governor, Lord Dalhousie, patron of the club, it is a bit awkward but full of charm. Prominent buildings are described with care, and as well as the garrison's splendid display of sleighs, two more humble local conveyances are posted left and right, an habitant sledge and a dog sled driven by a boy. That such winter holiday excursions led to a variety of extravagantly elegant vehicles, designed more for appearance than practicality, is satirized in a print based on a drawing by John Campbell. His tauntingly titled *New Brunswick Fashionables!!!* (Plate 20) parodies both the military precision of a proper club parade (or its lack among pretentious locals) and the profusion of details of local colour which by the 1830s had become a tiresome convention in such prints.

Such local colour became a virtue when it was pursued for its own sake rather than as an embellishment to the depiction of some garrison entertainment. By the early '30s many officers working in British North America were recording lively aspects of daily life in the colony. Among the best and most prolific was Lieutenant-Colonel James P. Cockburn. He seems to have sketched almost every day, and the hundreds of candid views he took on his regular tours of inspection throughout the colony are fascinating, involving images and a priceless record.

So many of his Quebec scenes survive that they constitute a near-complete record of the look of the place. Among them several winter scenes depict the effect of the freeze-up on the bustling capital, as in *Quebec from Château Saint-Louis* (Plate 18), or focus on characteristic winter activities. *Cutting Ice for the Summer at Quebec City* (Plate 5), of this latter type, describes the appearance of a lumber cove during hibernation, detailing the cutting of huge blocks of ice from the frozen river, hauling them out, and loading them on sledges. The special tools required – long whip-saws with a heavy weight for the down draw, long hooked pikes, and heavy axes and mallets – are casually but effectively displayed.

Upon his return to England at the end of the summer of 1832 Cockburn arranged to publish with Ackermann & Co., one of the largest London printmaking firms, two portfolios of six large aquatint views each of Canada, one devoted to Niagara Falls, the other to Quebec. The most beautiful prints of Canadian subjects of the period, they appeared in 1833, dedicated to King William IV, and the Niagara views were re-issued in 1857. Among the Quebec set are two winter scenes. One is of the by-then-traditional *Cone of Montmorency, as it Appeared in 1829* (Plate 9), a year when it grew to spectacular size. Other than a little fashion-plate showing local winter costume, the whole effort is turned to describing the cone and the crashing waterfall that engendered it. The other is of *The Ice Pont Formed Between Quebec and Point Lévi* (Plate 8). Once the St Lawrence had frozen solid, the ice bridged the city to the south shore. Evergreens marked the tested route. On particularly bright and still holidays, as Cockburn depicts, it became a grand boulevard for the inhabitants of the city, soldiers and merchants with their families, habitants and Indians, all mingling freely in the weak winter sunlight. The little wooden sheds are *auberges*, "inns" hauled on to

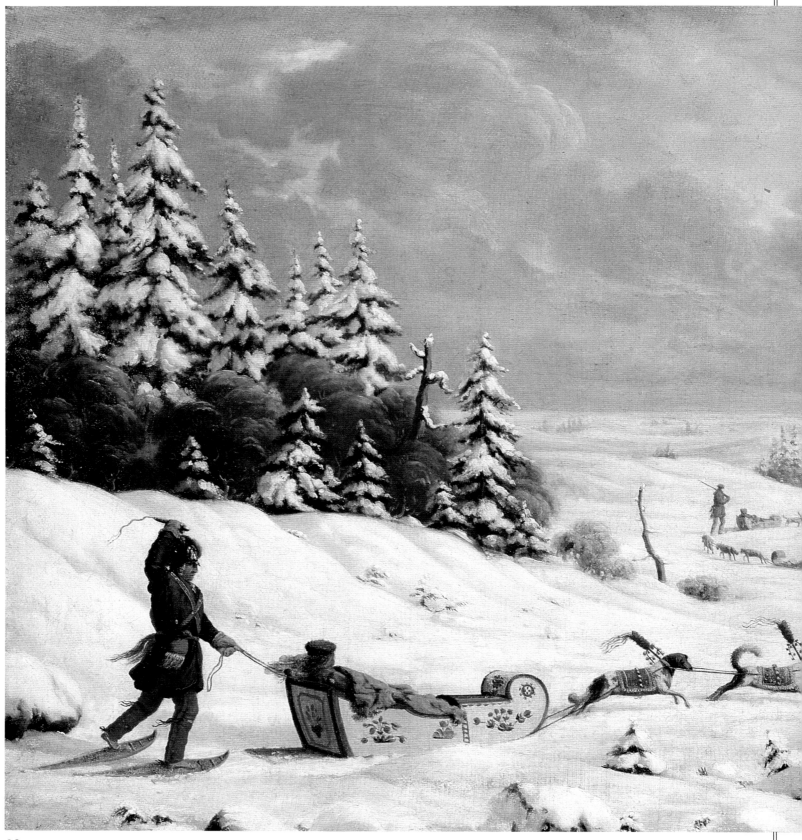

PAUL KANE
**Winter Travelling in Dog Sleds**
1851, oil on canvas, 48.2 × 71 cm.
Royal Ontario Museum, Toronto (912.1.48)

the ice for the season, not to offer accommodation, however, but convenient drinking.

Looking at Cockburn's pictures, we almost forget a large, ever-present garrison occupied Quebec. A few years later, following the abortive rebellion of 1837, the military increased, which

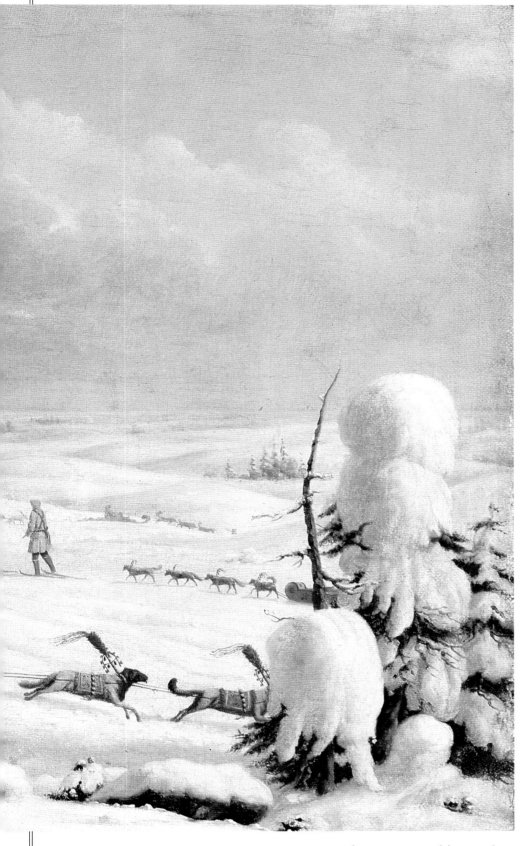

*River in Winter* (Plate 7), are sobering reminders of the deployment of armed force which was his reason for being here. A little unattributed watercolour of a dashingly elegant tandem sleigh (Plate 11), so low-slung it must have been designed for racing, is probably also by Bainbrigge (note the handling of the broken ice), a reminder both that hobbies still enjoyed importance, and that characteristic Canadian winter pursuits still fascinated these transitory artists.

Some natural phenomena, such as Niagara and the Montmorency ice cone, were regarded as natural monuments, must-sees for visitors, that typified the vastness and untamed energy of the New World. Other phenomena appeared only occasionally, such as the tremendous "ice shove" which built up in the river at Montreal some springs. Lieutenant-General Sir Henry William Barnard observed it in 1840 (Plate 6), and his wonderful watercolour painting suggests this momentous, frightening expression of the power of nature was as memorable a sight as he would see in more than forty years of service around the Empire.

The most ambitious officer-artist to serve in British North America during the period of the rebellion was Lieutenant Richard Levinge whose five-year posting was the highlight of his relatively brief military career. Unlike so many of his colleagues, Levinge did not remain a career soldier, nor did he serve in any more far-flung part of the Empire. An accomplished artist, as we can see by the commanding composition of *Indians Stalking Cariboo* (Plate 12), painted during his New Brunswick posting, he was intensely interested in the details of native life. He was also interested in the life of his regiment and later wrote its history, vividly describing memorable incidents, including a winter march from Saint John to Montreal during the rebellion. He also recorded it in watercolour, *St. Lawrence River in*

meant more artists were working and featuring military matters more prominently in their work. Lieutenant P.J. Bainbrigge, involved directly in actions against the rebels, has left us many wonderful, intimate sketches of his travels throughout the Canadas which show "normal" civilian life; but many, such as *Expedition on the St. Lawrence*

## Lieutenant Philip John Bainbrigge

Born into a military family at Lichfield, Staffordshire, in 1817, he joined the Royal Engineers upon graduating from the Royal Military Academy at Woolwich, 1833. Posted to Lower Canada in 1836, he was involved in operations against the rebels there the following year. He travelled extensively throughout British North America before returning to England in August, 1842. Appointed Instructor of Fortifications at Woolwich in 1845, he attained the rank of major-general at retirement in 1863. Died at Blackheath, England, 1881.

## Lieutenant-General Sir Henry William Barnard

Born at Wedbury, England, 1799, the son of a minister and amateur topographical artist. He joined the Grenadier Guards upon graduation from the Royal Military Academy at Sandhurst in 1814, and remained with the regiment throughout his life. Posted to Quebec in 1838, he served there and in Montreal until 1842. He later saw service in the Crimea, among other places, and died of cholera in Bengal, India, in 1857, having attained the rank of major-general.

## Lieutenant Richard George Augustus Levinge

Born in England in 1811, he was commissioned in the 43rd Regiment of Foot in 1828. Posted to British North America in 1835, he served first at Saint John, New Brunswick, and then with forces assigned to suppress the Rebellion of 1837 in Lower and Upper Canada. Returning to England in 1840, he retired from active duty when he succeeded to a baronetcy in 1848. Settling at Westmeath, Ireland, he entered politics, and published several books, usually illustrated after his sketches. He died there in 1889.

## Lieutenant Henry James Warre

Born into a military family at the Cape of Good Hope in 1819, he entered the Royal Military Academy at Sandhurst in 1832, and was commissioned in the 54th Regiment of Foot upon graduation. He was posted to Quebec in 1839 as aide-de-camp to the new Commander-in-Chief of Forces in British North America, Sir Richard Downes Jackson, his uncle. In May, 1845 he and Mervin Vavasour were sent to the Oregon Territory disguised as gentlemen-adventurers. Back in Quebec in July, 1846, he returned to England the following month. He later served in the Crimea, Egypt, New Zealand, and other places, and was Commander-in-Chief of the Army in India in 1878. He retired with the rank of general in 1886, and was that year named Knight Commander of the Order of the Bath. He died in London in 1898.

*Winter; the 43rd Regiment Marching to Canada from New Brunswick* (Plate 13), which depicts a view of the St. Lawrence at 7 a.m., December 23, 1837, with the temperature at –30 degrees Fahrenheit, in a stiff breeze. Writing about it thirty years later, Levinge recalled the impact that this, "one of the most remarkable movements on record," had upon the rebels. "The Moral influence of this march was immense. It struck the heart of the disaffected, crushed every hope they had entertained from the sympathy of the sister provinces, and convinced the world that there is no season at which Britain cannot reinforce her colonies, while she possesses soldiers whose dauntless spirits never quailed before a foe, or recoiled from any trial or exertion, however rigorous or severe."

Levinge arranged to have two of his elaborate paintings of garrison life lithographed in London even before he left Canada in 1840. The first, which shows the regimental sleigh club before the Saint John barracks in 1837, was published by T. McLean the following summer. (Plate 10). The second, with the club "turned out" at Niagara Falls in 1839, was published later that year by Ackermann & Co. (Plate 1). They are wonderful examples of their type, full of life and rich in detail. The Saint John scene is more dignified, with the sleighs arranged to show off the elaborately displayed pelts which had become a fashionable part of such events. One sleigh, hitched to a handsome tandem team and bearing noble arms, even carries a massive set of moose antlers. The Niagara scene, with more than one sleigh in deep trouble, is reminiscent of the plight of the New Brunswick Fashionables. The officers are identified below the image, and at least three of them, including Levinge, we know were active artists.

As mid-century approached, the importance of the soldier-artists diminished. Troops were reduced as the rebellion scare subsided, and the civilian population had been growing steadily for decades. At least one more talented artist should be mentioned. In 1845 Lieutenant Henry James Warre received a plum of an assignment when he and another officer, disguised as gentlemen adventurers, were sent to the Pacific Coast to determine if overland transport of men and materiel sufficient to hold the lower Columbia River region was feasible. The trip there and back took more than a year and was full of exciting incidents, all of which Warre chronicled in a volume of lithographic prints with text he published in London in 1848. He had made a few sketches of Montreal's wintry streets before his western excursion, but they hardly prepared him for the snow they encountered in Athabasca Pass in the Rockies on their return in May, 1846. His sketch depicts the laborious climb through the deep, wet stuff "which sank, even with the snow shoes, nearly to the knees at every step." (Plate 75)

**Alicia Killaly**

Born in London, Upper Canada, in 1836, the daughter of Hamilton H. Killaly (1800-74), a canal and railway developer in Quebec and Ontario. Resident in Quebec City and then Montreal in the 'forties and early 'fifties, the family settled in Toronto in 1855, although government dealings perhaps would have taken them all to Quebec during the period prior to Hamilton's retirement in 1862. In 1871 Alicia, who is supposed to have studied with Krieghoff, married Christopher H. Turnor, recently retired Lieutenant in the Prince Consort's Own Rifle Brigade, and settled in England. She died at Grantham, Lincolnshire, in 1916.

Canada must have seemed a minor interlude in the lives of such careerists, the memories of incidents only faintly recalled in spite of souvenir drawings and prints. Yet there were often ties which resulted from Canadian postings. A set of six chromo-lithographs published in 1868 in Ottawa, capital of the new Dominion of Canada, tells the story of a romantic interlude between Captain Buzbie and Miss Muffin, and the unsettling consequences when the Captain failed to pay enough attention to the road on their return from *A Picnic to Montmorenci* (Plate 19). Hardly

important works of art, these prints show the persistence of a traditional, socially significant activity of the garrison to the end of its tenure in Canada. The last British troops left in 1870, their places taken by forces raised in the Dominion itself. There would be no more muffins, but one of their number made this record, it seems, just before the rituals disappeared. Alicia Killaly – her descendents believe she was the author of the prints – was wooed by a handsome British lieutenant about the time they were made. This Miss Muffin married him and spent the rest of her days in England.

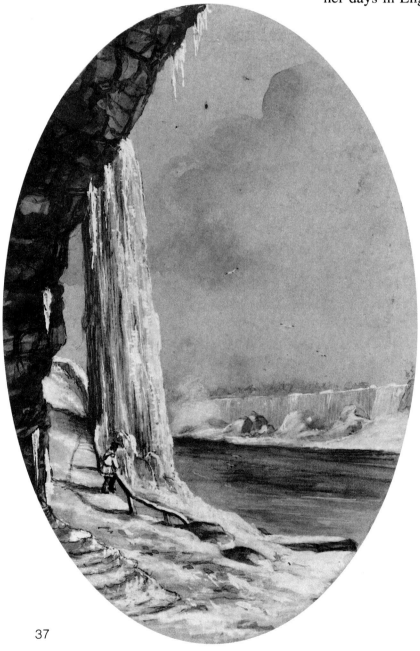

37

**WILLIAM ARMSTRONG**
**Icicle at Niagara**
1855-56, watercolour, 20.7 × 13.1 cm.
Royal Ontario Museum, Toronto (965.138.8)

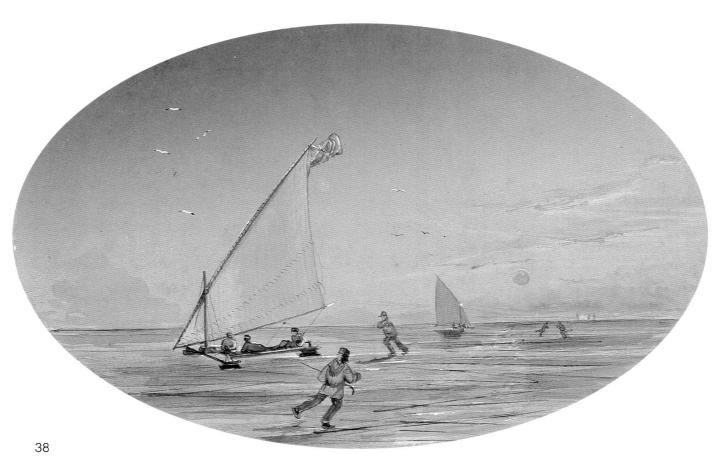

38

**WILLIAM ARMSTRONG**
**Toronto Ice Boat**
c.1855, watercolour, 13.1 × 20.7 cm.
Royal Ontario Museum, Toronto (965.138.14)

39

**WILLIAM H.E. NAPIER**
**Tobogganing**
c.1855, watercolour, 12.5 × 16.5 cm.
National Archives of Canada, Ottawa (C-98710)

40

JAMES DUNCAN
**Lady Swells, Officer and Muffin**
c.1859, watercolour, 23.2 × 33.3 cm.
Royal Ontario Museum, Toronto (951.158.16)

41

JAMES DUNCAN
**Montreal Swells**
c. 1859, watercolour, 23.2 × 33.3 cm.
Royal Ontario Museum, Toronto (951.158.16)

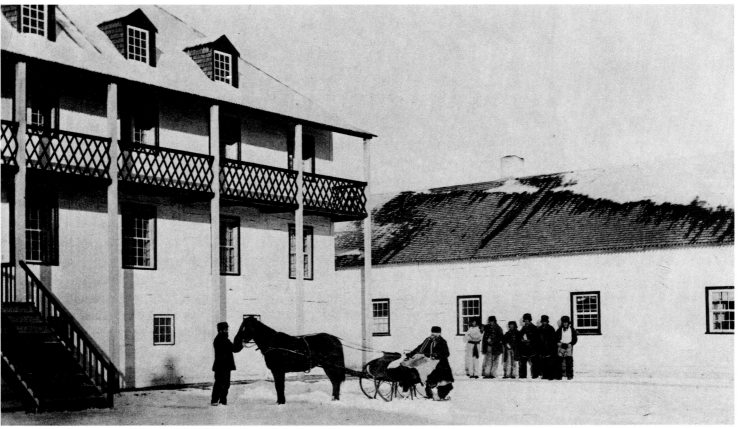

42

CHARLES HORETZKY
**Interior of Fort Edmonton**
1871, albumen print, 15.5 × 20.5 cm.
National Archives of Canada, Ottawa (C-7476)

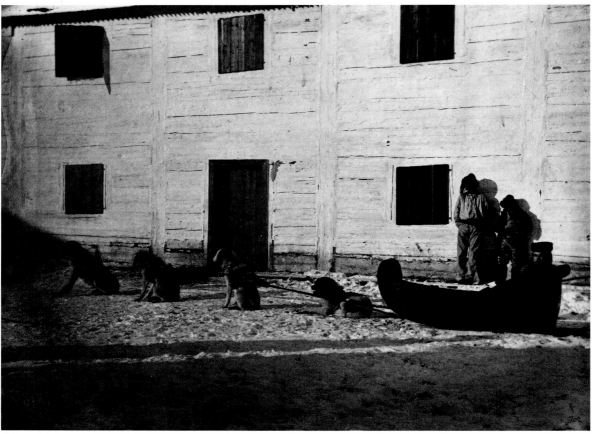

43

CHARLES HORETZKY
**Cariole and Team, Fort Garry**
1872, albumen print, 15.5 × 20.5 cm.
National Archives of Canada, Ottawa (PA 9174)

44
WILLIAM G.R. HIND
**Breaking a Road in Winter in Manitoba**
c.1870, oil on board, 20.4 × 25.5 cm.
National Archives of Canada, Ottawa (C-13977)

45
WILLIAM G.R. HIND
**Winter Hut, Nova Scotia**
c.1880, watercolour, 24.8 × 35.6 cm.
National Archives of Canada, Ottawa (C-13978)

46
OVERLEAF:
WILLIAM G.R. HIND
**Horse Drinking at Ice Hole**
c.1870, oil on board, 23.4 × 31.1 cm.
National Archives of Canada, Ottawa (C-13972)

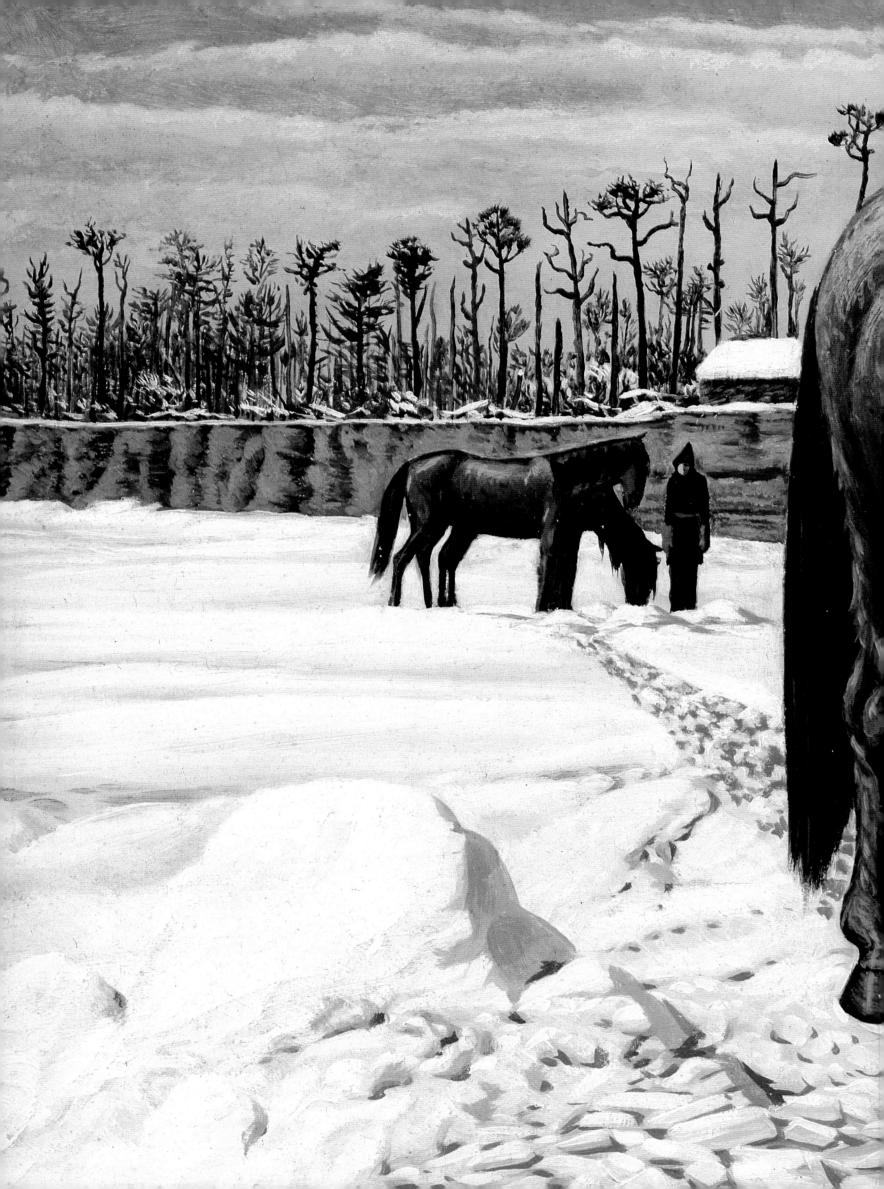

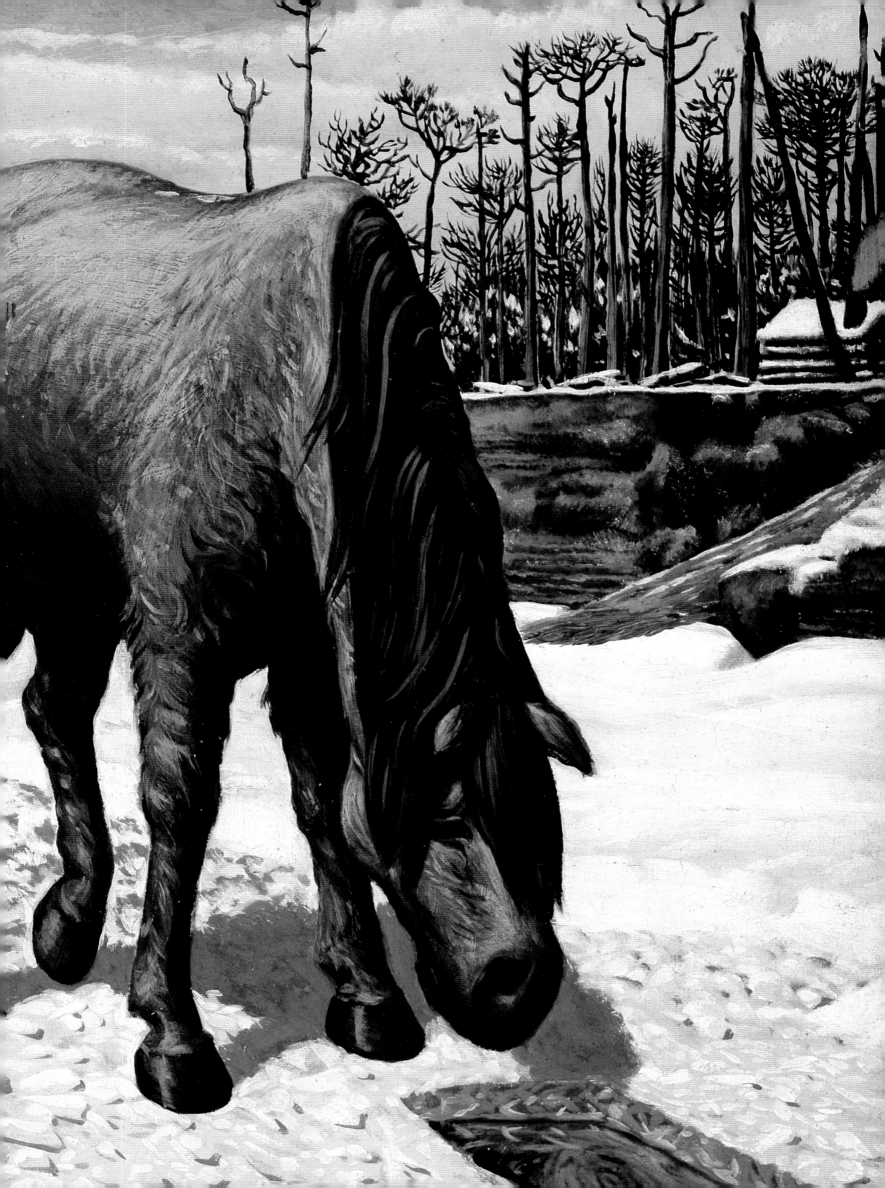

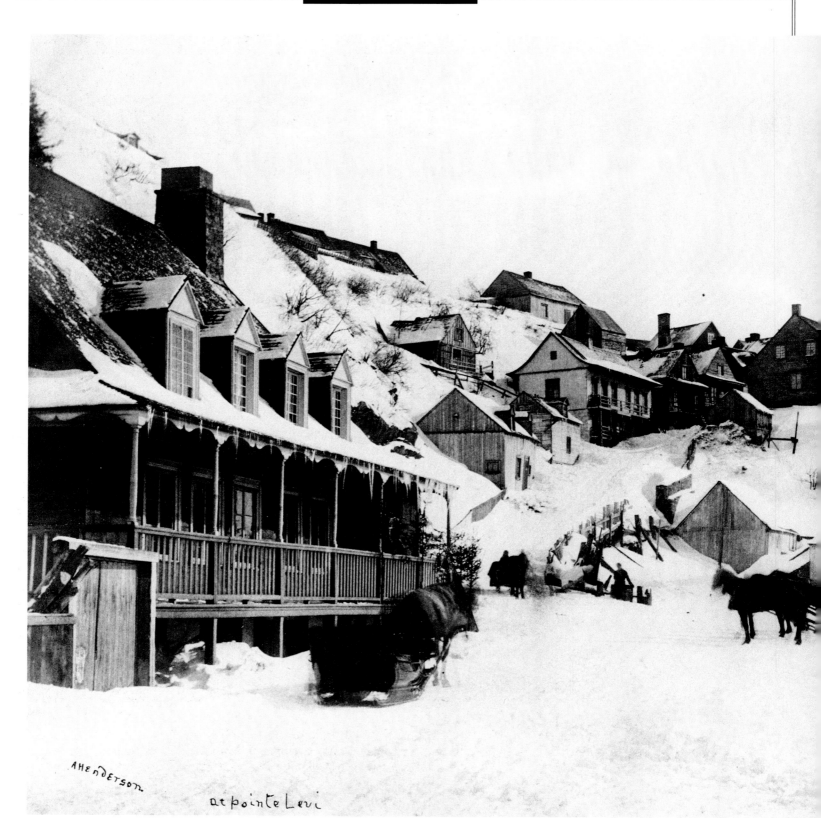

47

ALEXANDER HENDERSON
**At Point Lévi, Quebec**
c.1870, albumen print, 15.5 × 21.2 cm.
National Archives of Canada, Ottawa

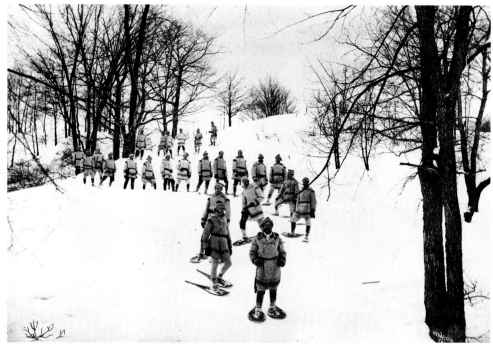

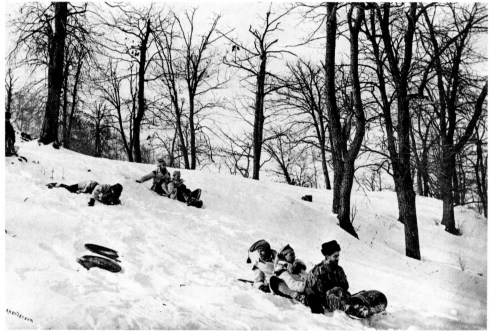

48

ALEXANDER HENDERSON
**Album Page,**
**Snowshoeing Indian File, Quebec, and Tobogganing**
1878, albumen prints, 15.4 × 20.1 + 15.2 × 20.5 cm.
National Archives of Canada, Ottawa (C-22233, C-14971)

49
OVERLEAF:
WILLIAM NOTMAN
**Cariboo Hunting; The Return of the Hunters**
1866, hand-coloured albumen print, 51.2 × 61.3 cm.
Notman Photographic Archives, McCord Museum of Canadian History,
McGill University, Montreal

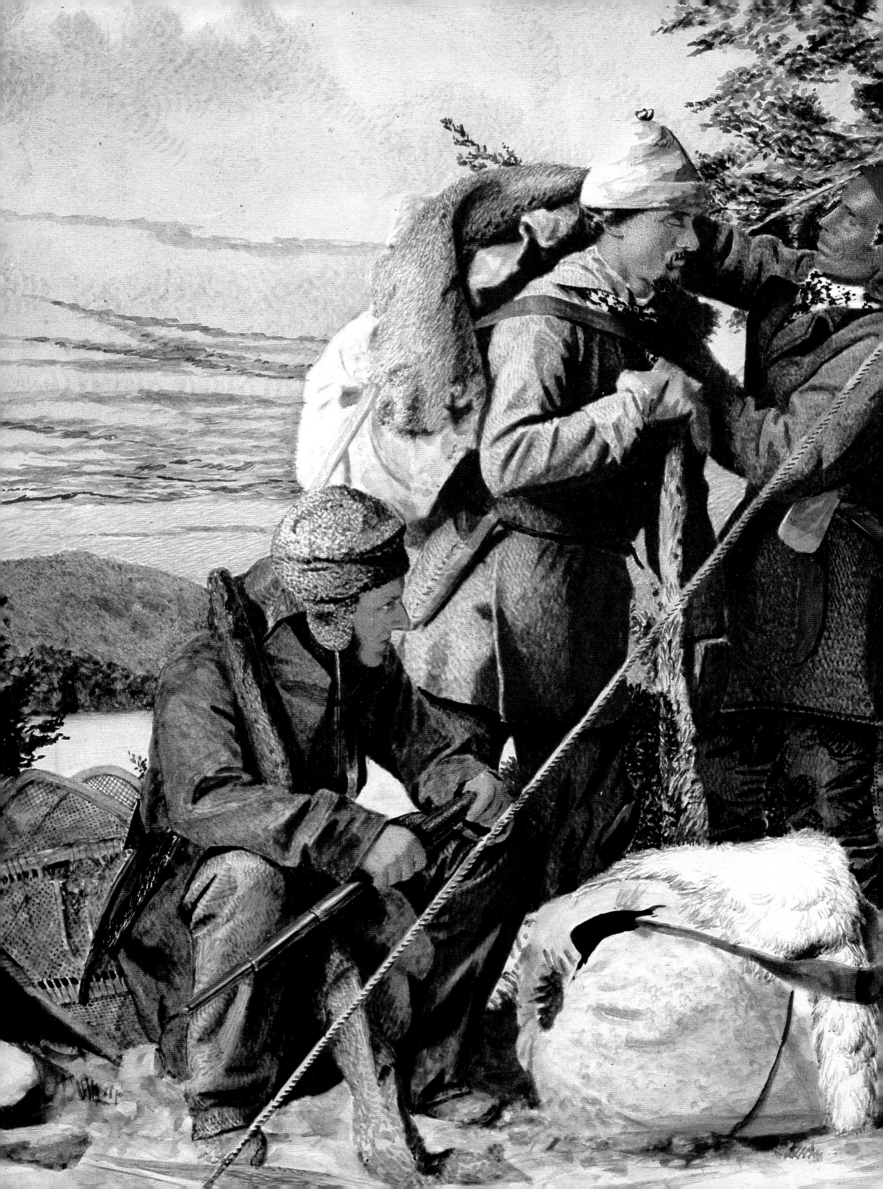

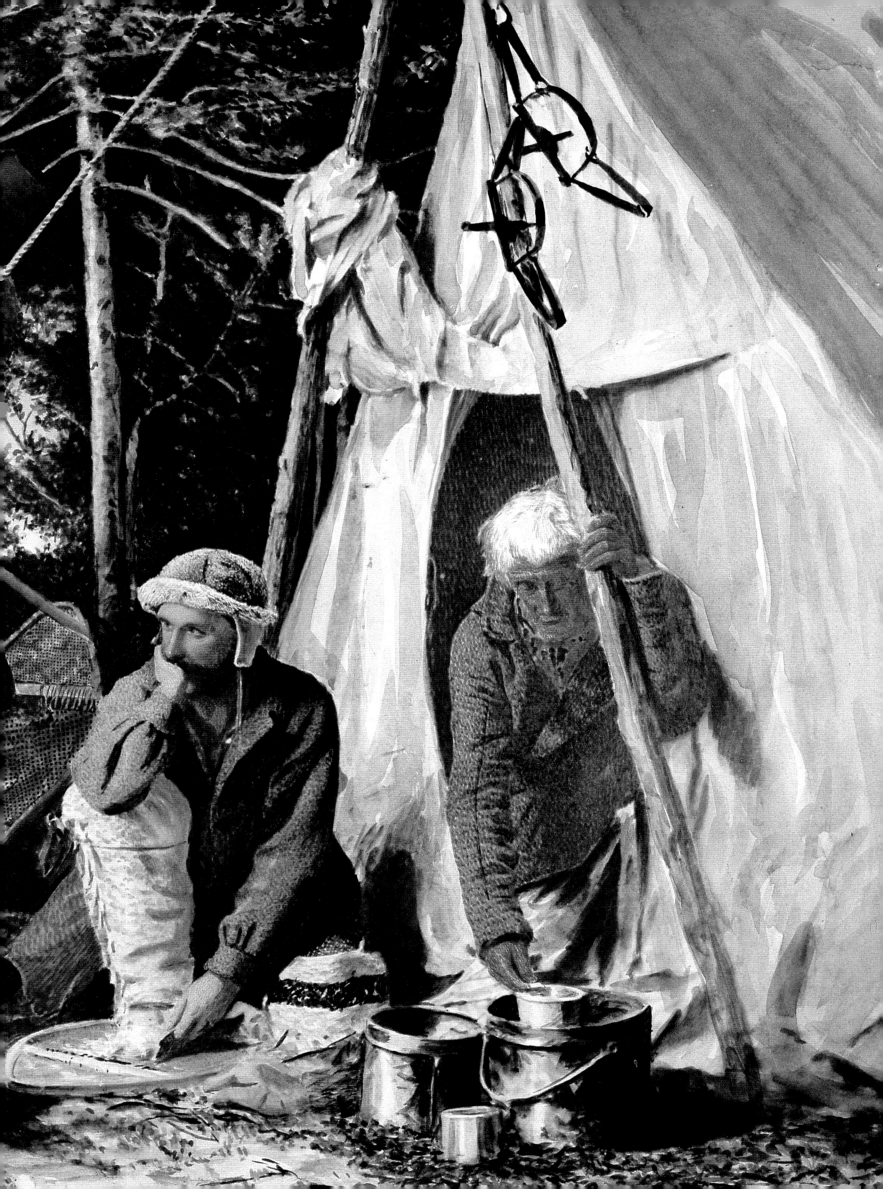

50  ALEXANDER HENDERSON
**Edge of the Bush in Winter**
1865, albumen print, 16.2 × 21.6 cm.
National Archives of Canada, Ottawa (PA 28613)

51  CHARLES HORETZKY
**On the Peace River in the Heart of the Rocky Mountains**
1872, albumen print, 15.5 × 20.5 cm.
National Archives of Canada, Ottawa (C-9568)

52

ALEXANDER HENDERSON
**Valley Near Lake Beauport taken in a Snowstorm**
1865, albumen print, 15.9 × 21.6 cm.
Notman Photographic Archives, McCord Museum of Canadian History,
McGill University, Montreal (MP039/87)

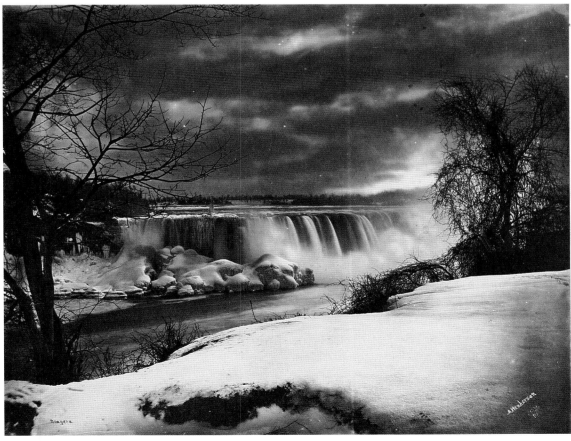

53

ALEXANDER HENDERSON
**Niagara**
c.1870, albumen print, 19.2 × 24.3 cm.
National Archives of Canada, Ottawa (PA 147567)

# DENNIS REID
# Professional Painters in British North America

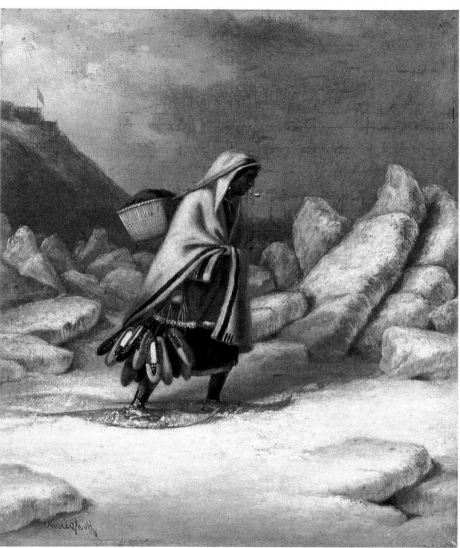

54

CORNELIUS KRIEGHOFF
**Indian Moccasin Seller, Quebec**
c.1860, oil on canvas,
31.7 × 21.9 cm.
Whyte Museum of
the Canadian Rockies, Banff,
gift of Catharine Robb Whyte

From the early decades of the eighteenth century professional painters worked in New France but, as I have noted, neither they nor the resident professionals of the early post-conquest period addressed the landscape, let alone the winter landscape. Other than in isolated instances which appear to relate to the tastes of the British community, the winter landscape did not interest francophone artists in the nineteenth century. Among the immigrant population the case was different. As the number of artists increased, so did the incidence of winter scenes. As we might expect, the landscapes of the earliest professionals concerned with such subjects were similar to those of the soldier-artists. Based on essentially the same models, they fulfilled a like function: recording characteristic local life and the environment for visitors or family and friends in the old country. By 1850 they start to address the concerns of those who had made a commitment to living in Canada.

Among the earliest immigrant painters of notable talent was a Swiss boy of fifteen who settled with his parents and a boatload of other Swiss in the Red River Colony in 1821. Peter Rindisbacher could hardly then have been called a professional, but he was talented, had had some art training in Berne, and created images of lasting importance. Fascinated with the ways that the natives survived on the land, he detailed activities such as buffalo hunting undertaken in the late winter when the snow was soft, slowing the buffalo so they could be attacked by hunters on showshoes (Plates 14, 15). Meticulously executed and composed with a sense of drama, these beautiful, informative, unique pictures depict life on the edge of the great western plain before European settlement disrupted its basis. Their quality was recognized and young Rindisbacher was encouraged as an artist by the Hudson's Bay Company and government officials who bought his work. One patron even had six of his scenes published by a London lithographer, although the young artist was given no credit; the views were described simply as "Taken by a Gentleman on the Spot," in the manner

## Peter Rindisbacher

Born in the Upper Emmenthal, Berne Canton, Switzerland, in 1806, he trained with the Berne miniaturist, Jacob S. Weibel, his sole teacher, the summer of 1818. A talented water-colourist and miniaturist by 1821 when his family emigrated to the Red River Colony, he sold paintings of local Indians there, and his views of the region were published in London in 1824 and 1825. Driven out by severe flooding in 1826, his family settled at Gratiot Grove on the Wisconsin-Illinois border, where he continued to paint Indian scenes for local sale. He moved to St. Louis, Missouri, in 1829, where he established himself as a professional artist, and where he died suddenly in 1834.

used to refer to the work of his military contemporaries.

Most immigrants were drawn to the settled parts of British North America during the early nineteenth century, and the painters among them gravitated to urban centres. Their work was similar to that produced in the garrisons, but we see subtle differences, such as the prominence given significant local businesses in Robert Sproule's 1829-30 *Saint James Street, Montreal* (Plate 17), prepared as the basis for one of a set of engravings published in Montreal that year. Although the garrison was greatly influencing the cultural aspirations of the civilian community, William Eagar's 1839 lithograph of the *Tandem Club*

*Assembling in Front of Dalhousie College, Halifax, N.S.* (Plate 30) does not reveal one evident military member.

A new type of artist who began to appear during the late '40s accelerated such tendencies. Often trained as architects or engineers, they usually followed scientific developments, and were otherwise interested in the world around them. Like their army coevals, they were expected to know something of geology and other natural sciences. At mid-century railroad development was often the focus of their professional interest, and the achievements of photography – that new technique which relied on the contributions of science – played an important role in their image-making. The foundation of their painting was still that topographic-picturesque tradition that had served the military visitors so well, but to an unprecedented degree their landscapes addressed the aspirations of a rooted, rapidly growing local community. Among these artists were many, like William Napier of Montreal, whom today we would call amateurs, even though painting was a lifelong interest.

The exemplar of the type is a man who worked as an engineer on railway construction, as a topographer and photographer, who was engaged professionally with geologists and explorers, invested in the development of natural resources in Ontario, and whose constant interest in art-making dominated his other interests in his later years. Following his immigration to Toronto in 1851, Dublin-born William Armstrong committed himself to Canadian growth and progress. Winter did not figure in most immigrants' views of Canada's potential, but for Armstrong, particularly in his first decade in the country, the rigours of winter, part of life in the New World, could not stand in the way of progress. The three small oval views of 1855-56 reproduced here (Plates 33, 37, 38) determinedly celebrate winter, its frozen

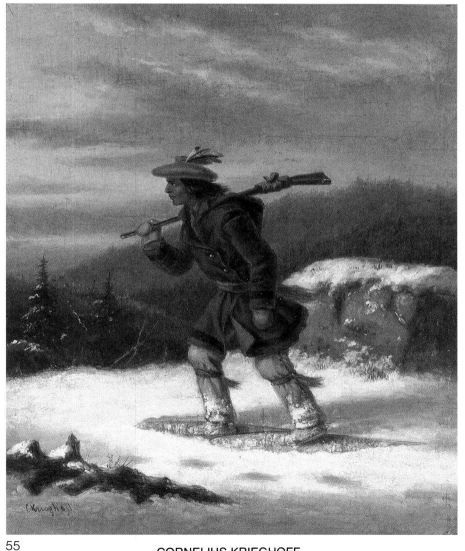

55

**CORNELIUS KRIEGHOFF**
**Tracking the Moose**
c.1860, oil on canvas, 26.1 × 21.9 cm.
Whyte Museum of the Canadian Rockies, Banff, gift of Catharine Robb Whyte

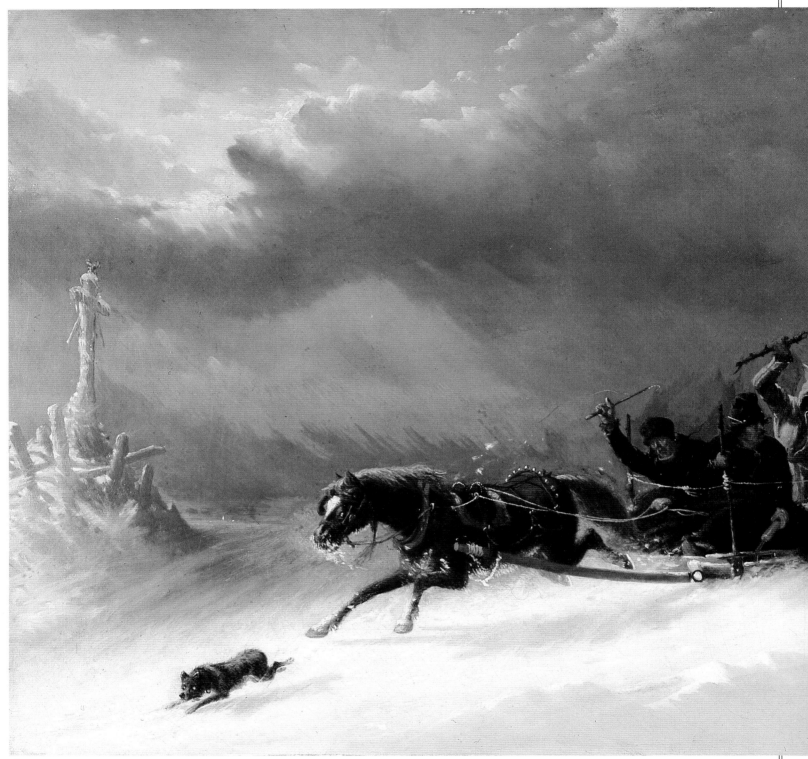

56

**WILLIAM RAPHAEL**
**Habitants Attacked by Wolves**
1870, oil on canvas, 60.3 × 106 cm.
Montreal Museum of Fine Arts, gift of the Misses Scott, 1923 (923.373)

### Robert Auchmuty Sproule

Born in Athlone, Ireland, in 1799, he
was educated at Trinity College,
Dublin, graduating in 1821.
Emigrating to Canada about 1826,
he settled in Montreal where he
painted miniatures on ivory and
watercolour landscapes. He is best
known for views of Montreal and
Quebec and small devotional images
and portraits produced with the
Montreal print-maker Adolphus
Bourne in the early 1830s. Moved to
Upper Canada c. 1840, and died at
March, Upper Canada, in 1845.

### William Henry Edward Napier

Born in Montreal in 1829, he was
trained as a civil engineer, and later
worked on the construction of the
Grand Trunk Railway and for a time
in the mid-fifties on the Toronto-
Guelph-Sarnia line, where he
associated with William Armstrong. A
member of the Canadian
Government Exploring Expedition to
the Red River Colony in 1857, he
worked for the Intercolonial Railway
1864-70. He moved to Britain in
1870, and died at Edinburgh 1894.
Although he sketched throughout his
years in Canada, he apparently never
sought more than amateur status as
an artist.

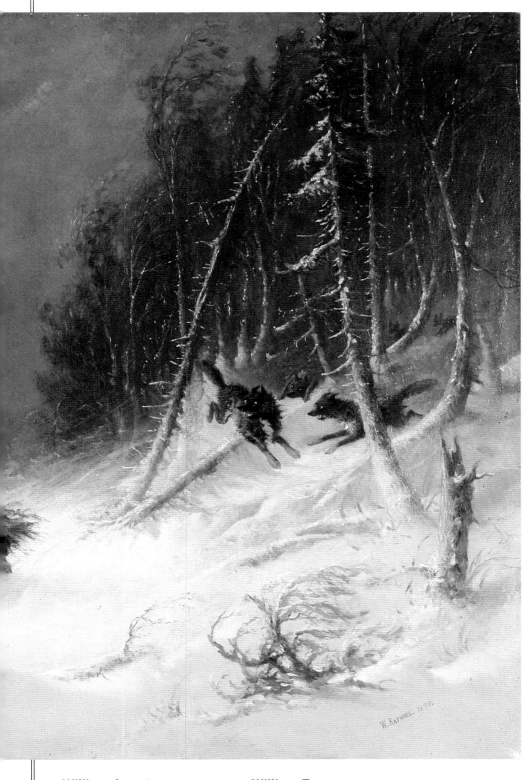

water tanks, giant icicles at Niagara, and ice boating, that most spectacular winter sport. These three views by Armstrong come from an album assembled by his associate, Frederick J. Rowan, the engineer in charge of building the section of the Grand Trunk Railway between Toronto and Belleville.

By the 1850s professional artists were creating works at even more distance from the dominating documentary concerns of the military men. The itinerant portraitist and landscape painter F.W. Lock certainly sought to create a romantic illusion as much as to satisfy intellectual curiosity in his 1856 lithographic view of Niagara in winter (Plate 24), which depicts the artist splendidly isolated in an icy fantasy world which was by that date a busy, commercial tourist attraction.

### William Armstrong

Born in Dublin, 1822. Trained as a civil engineer, he worked in Liverpool, London, and Dublin as an engineer-draughtsman until emigrating to Toronto in 1851. An effective topographical artist, he began exhibiting soon after his arrival. He also found work as an engineer, first with the Northern Railway, and then with the Grand Trunk Railway, 1856-61, while a partner in the firm of civil engineers and photographers, Armstrong, Beere, & Hime, 1857-62. About 1864 he took a position as art instructor in the Toronto Normal School, which he held until 1883. He continued active as an artist and illustrator for many years. Died in Toronto, 1914.

### William Eagar

Born in Ireland in 1796. Little is known of him until he emigrated to St. John's, Newfoundland, some time before 1819. He tried to support himself and family there with portraiture and teaching, and a view was published in 1831. He moved to Halifax, Nova Scotia, in 1834, where he again taught drawing and pursued portraiture, but he is today best known for topographical views in Nova Scotia and New Brunswick, some of which were published. Died in Saint John, New Brunswick, 1839, while returning from a business trip to England.

### Frederick W. Lock

Nothing is known of his early years in England. He arrived in Canada in 1847 and worked as an itinerant landscape and portrait painter in watercolour and pastels between Montreal and Toronto and their hinterlands to about 1852. He settled in Montreal, but moved to Brockville, Canada West, following his marriage in 1855. He returned to England after his wife's death in 1860, where he lived at Bury St. Edmonds, Suffolk.

### James Duncan

Born at Coleraine, Ireland, he apparently worked there as an artist and teacher. Emigrated to Montreal c. 1830, where he established himself as an artist, painting landscapes and city scenes in watercolour and oils, and prepared designs and illustrations in pen and ink. He also worked as a photographer in the mid-fifties, and taught drawing throughout his life. A member of the Montreal Society of Artists in 1847, the Society of Canadian Artists, 1868-72, and an Associate of the Royal Canadian Academy in 1881, he exhibited widely. Died in Montreal in 1881.

### Cornelius David Krieghoff

Born in Amsterdam, 1815, and raised in Dusseldorf and Schweinfurt, Bavaria, he probably studied at the Dusseldorf Academy. He emigrated to New York City 1836, and served in the U.S. Army 1837-40. Resident in Montreal in 1841, he moved to Rochester, N.Y., until late 1843. He visited Toronto briefly in 1844, then returned to Europe, passing the winter of 1844-45 in Paris. Returning to Montreal, he worked there until 1853, painting scenes of local life, emphasizing habitants and Indians. He also did some portraiture and teaching, and was a member of the Montreal Society of Artists in 1847. He moved to Quebec City in 1853. Returning to Europe, probably late 1863, he was back in Quebec briefly in 1867, before living in Chicago, 1868-70. He was back in Quebec, August, 1870 until late 1871, then returned to Chicago, where he died, 1872. Probably the best-known artist of his day in Canada.

James Duncan in Montreal also sought to develop self-conscious aesthetic values in what remained at base an art documentary in purpose. Irish-born, he pursued a career entirely as a painter and teacher. His larger works in watercolour, or sometimes oil, which he painted either for exhibition and sale or on commission, exemplify this dichotomy. *The Quebec Tandem Club, Champ-de-Mars, Montreal* (Plate 21) has a wonderful sweep of movement, a sense of flashing colour, and an attention to atmosphere that adds a new note to what had become a traditional Canadian winter theme. Yet it does not contain the information, the detail and precision of the work of Lieutenant Levinge or even of William Eagar. His sketch material is more satisfying. Hundreds of pages from his sketchbooks have fortunately survived. Gems of observation such as *Montreal Swells* (Plate 41) tell us a great deal about the winter fashion of the day, while functioning as a small slice of contemporary city life. *Lady Swells, Officer and Muffin* (Plate 40), which also includes an Indian woman, is similarly a fashion plate study that conveys the vibrancy of Montreal's street life. Equally evocative is a set of small watercolours depicting three stages in an Indian couple's hunting trip (Plates 25–27). Based on venerable Canadian traditions, these scenes go farther than had been the usual practice in creating a mood which in turn stimulates rich emotions. His, by the way, is the only picture I know of Indians sliding downhill on a toboggan.

Duncan maintained a respectable living as a painter, but never achieved celebrity. His near-contemporaries Paul Kane and Cornelius Krieghoff, while failing to amass fortunes as painters, did achieve measures of fame. Each in his own part of the country was the artist whose work set the standard by which others were measured. Each devoted his career to systematically creating distinctive Canadian art. Both differ from their predecessors in one regard. They both believed the quality of the Canadian achievement which their work represented rested not only on what they painted, but on how they painted. Their pictures functioned not only as information, but as symbols of the contiguity of Canadian painting with Europe's grand traditions. Not the first in Canada to express such ambitions, they were the first to link a resonant European style to varied bodies of Canadian images.

Krieghoff, who painted a remarkable number of winter scenes, is easily the champion of the subject in nineteenth century Canadian art. Is this simply because of his single-minded pursuit of the *typically* Canadian? Likely not, for if it were the case, we would expect to find as large a percentage of winter scenes among Paul Kane's works. It appears Kane painted only two such canvasses in his career. One, of which a later replica may or may not be his, (Plate 4) is a portrait of Captain John Henry Lefroy of the Royal Engineers, a personal friend. The original picture was likely painted in the winter of 1845-46, before Kane visited the west, and it was exhibited first in April 1847, as *Scene in the North-West – Portrait*, while Kane was travelling on his epic journey to the Pacific coast and back. Perhaps the replica was made when Lefroy returned to England with the original about 1855.

## Paul Kane

Born in Mallow, County Cork, Ireland, 1810, he emigrated to York (Toronto) with his family c. 1819. With the training he gained locally he worked as a decorative painter in a furniture shop before establishing himself as a portraitist in Cobourg, Upper Canada. To Detroit, Michigan, 1837, and on to Mobile, Alabama, 1840, he sailed to Europe 1841, travelling in Italy, Switzerland, France, and to London. He returned to Mobile, 1843, and Toronto late the next year. The summer of 1845 he passed sketching Indians around Lakes Huron and Michigan. From May, 1846 to October, 1848 he travelled cross-country to the Pacific coast and back, sketching Indians, and devoted the next eight years to making a cycle of 100 paintings documenting the tribes he observed, and writing a book of his journey. Failing eye-sight forced him to stop painting c. 1860. Died in Toronto, 1871.

## William George Richardson Hind

Born in Nottingham, England, 1833. Little is known of him before he settled in Toronto in 1851. Served as Drawing Master at the Toronto Normal School, 1851-57, after which he returned to England. In Canada in 1861 he joined his brother's exploration up the Moisie River into Labrador as expedition artist. The following spring he joined the "Overlanders" in Toronto on a cross-country trek to the Cariboo gold fields of British Columbia. In San Francisco by November, he settled in Victoria, B.C., in January 1863, where he remained, working as an artist, until 1869. He contributed drawings to the *London Illustrated News* from Winnipeg, Manitoba, early in 1870. In New Brunswick by late in the year, he lived in various places about the Maritimes until settling in Sussex, N.B., 1879. Died there 1889.

Kane based his second winter canvas which survives, *Winter Travelling in Dog Sleds* (Plate 36), on sketches he made of a wedding party departing Fort Edmonton in January 1848. Kane had much experience of snow during the two winters he spent in the west and brought back some sketches. But the fact is stubborn: he painted only this one canvas of a sort proliferating in Krieghoff's hands. The reason is straightforward. Kane established his ideal of art during a study trip to Europe between 1841 and 1843, deriving it from the example of French and Italian masters. There is no tradition of painting snow in either school. Krieghoff, born in Amsterdam, raised in Dusseldorf and Bavaria, likely studied at the Dusseldorf Academy. The ideal of art upon which his canvasses are based is Dutch and German. There is a highly developed tradition of snow painting in these schools, which reached a level of excellence in seventeenth century Holland, and in turn served as the model for a revival in early nineteenth century Holland just when Krieghoff was growing up. A sudden increase in the number of winter landscapes in the United States at the middle of the century has been attributed to a similar interest in the art of Dusseldorf and the related Dutch schools.

Krieghoff's earliest wintry scenes of habitant life reveal his use of many conventions of seventeenth century Dutch landscape painting as well as the devices the Dutch used to depict ice and snow effects. He soon incorporated what he found of a Canadian tradition, as in his *Montmorency Falls* (Plate 28), a version of which was issued as a print. His success was probably due to the way in which he adapted familiar Dutch genre themes to Canadian subjects, although almost always with a specific Canadian dimension, like the political colours worn by the horses of the habitants and English gentlemen in *Racing on the Ice* (Plate 22). Krieghoff's haunting wilderness scenes, such as

*Tracking the Moose on Lake Famine South of Quebec* (Plate 29), with its evergreens marking an ice bridge that seems to lead nowhere, attract us more today. Much as we may question the depth of Krieghoff's art, we cannot deny its basis in genuine Canadian experience.

One isolated, eccentric, but genuinely imaginative recorder of the life of his day must be mentioned. W.G.R. Hind is in the mould of the exploration artist. He accompanied his brother on an expedition into Labrador, later travelled with the Overlanders of '62 to the Cariboo gold fields, and passed the last twenty years of his life on the east coast, all the while painting what he saw around him. Hind didn't seek out winter scenes, and they are rare in his work. Returning from the west, he spent the winter of 1869-70 in Manitoba, where Peter Rindisbacher had lived fifty years before. Fascinated with the way the locals survived the harsh continental winter, as was the young Swiss, he recorded their efforts in small, intense oil studies. (Plates 44, 46) Their intensity and directness make them seem modern and freshly inventive. One striking later piece, which shows an Indian family's winter camp in the early spring, reveals his fusion of documentary intent with personal vision. (Plate 45)

57

OVERLEAF:
JOSEPH DYNES
**Falls of Montmorency,
Meeting of the Sleighs (detail)**
1867, oil on canvas, 92 × 121.9 cm.
Royal Ontario Museum, Toronto (948.197.1)

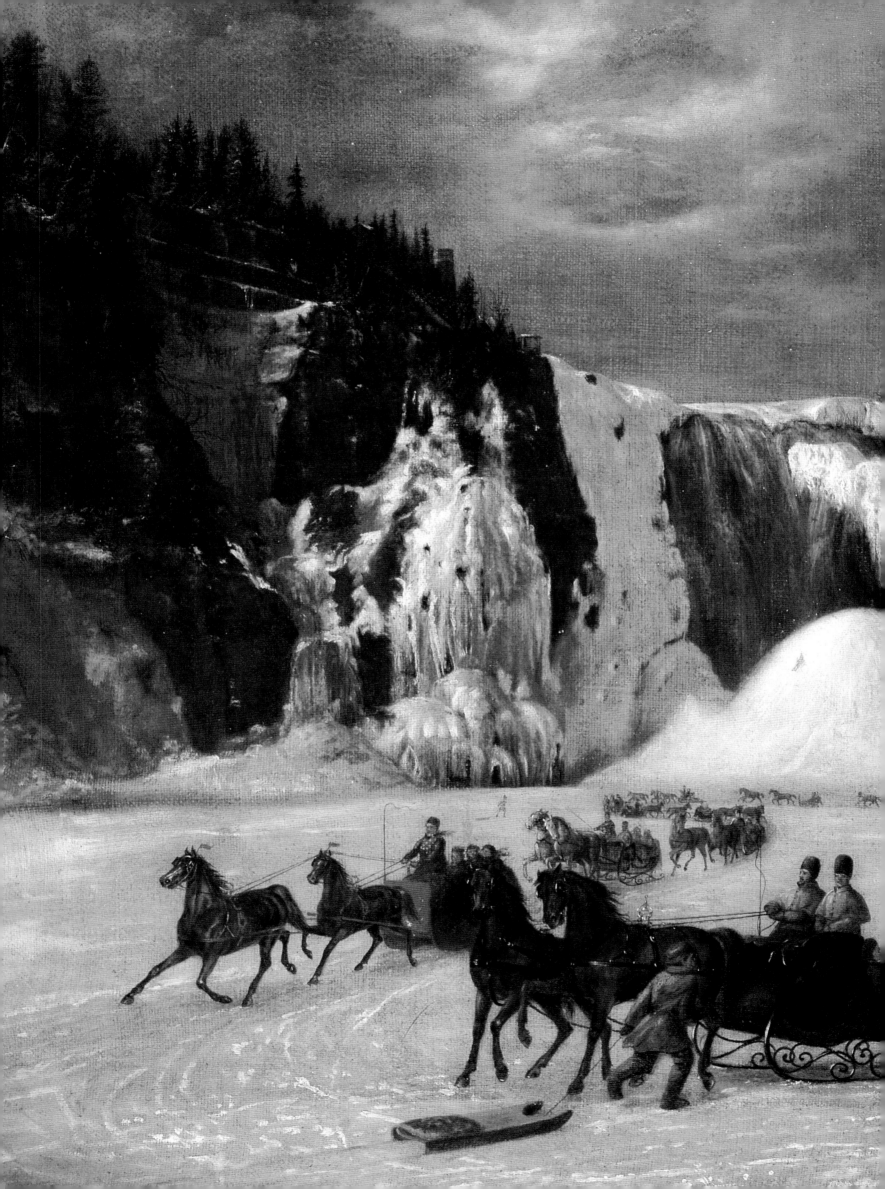

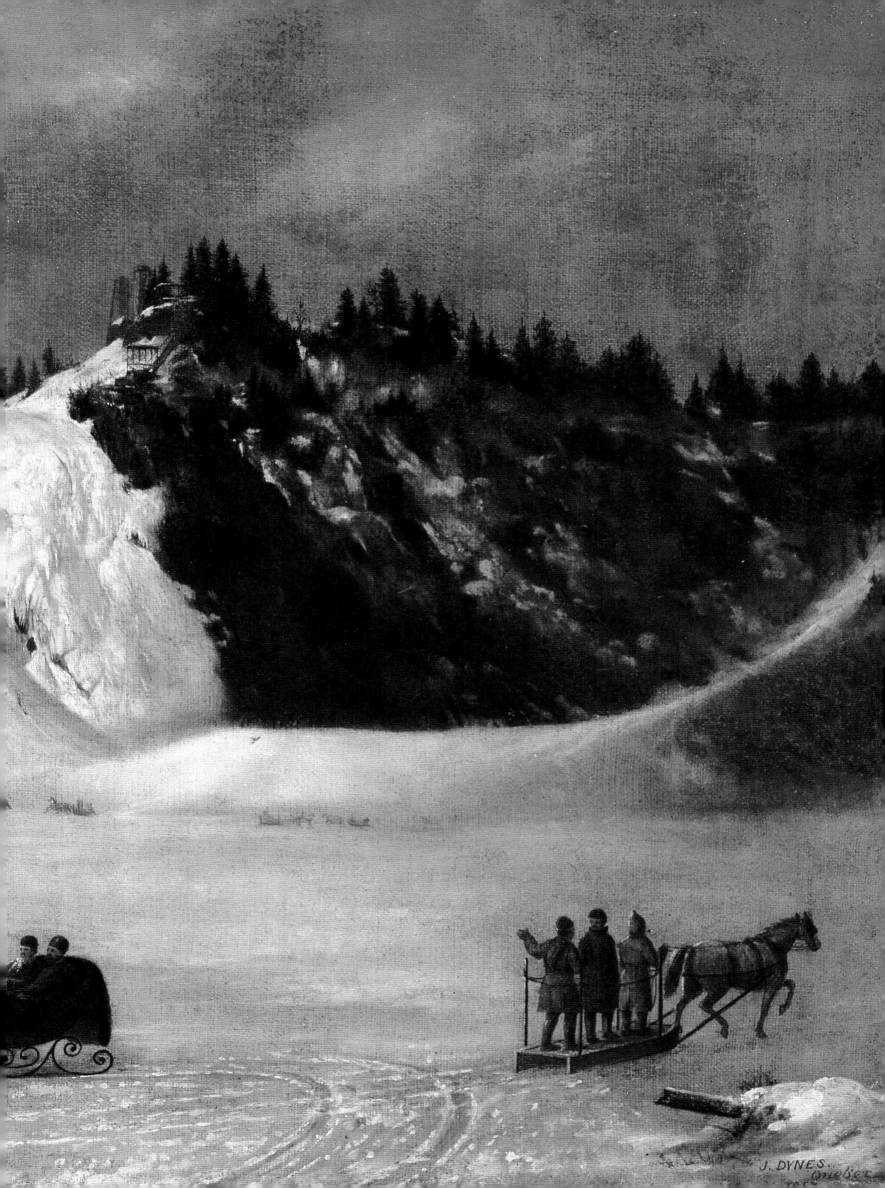

# EDWARD CAVELL
# Photography and Winter

58

**CHARLES HORETZKY**
**Jasper House Valley**
**Looking South**
1872, albumen print,
15.5 × 20.5 cm.
National Archives of Canada,
Ottawa (PA 9169)

◄ ATTRIBUTED TO
PAUL KANE
**Scene in the**
**North-West – Portrait**
**(detail)**
c.1855, oil on canvas,
56.2 × 76.5 cm.
Glenbow Museum, Calgary
(An.55.31.3)

The "art born of science" was a revolution in the 19th century. Photography was also a difficult and demanding medium that was awkward to use at the best of times and bordered on impossible in any extreme environment. Our subject has limited the inclusion of photography; the century was more than half over before the medium could be readily used in the winter. Introduced in 1839, it was considered by some as the death of painting. Excessive, yes, but indicative of the excitement surrounding the advent of the new medium. The concept of capturing "reality" in minute detail, free of the painter's exaggerating hand, thrilled people.

The selection here has been restricted to the three photographers who consciously used the theme of winter in their work rather than as a happenstance: Alexander Henderson, Charles Horetzky and William Notman. In Victorian Canada there was considerable professional crossover in the visual arts, with painters often working as or for photographers, as Dennis Reid observes. Considered equals in the community, both Henderson and Notman were instrumental in establishing the Art Association of Montreal. Photographers were also a part of the larger art world, influenced by its trends and current aesthetics. Their photography often emulated what they admired in the other visual arts. Notman's composites are perhaps the best, if the most excessive, examples of photography following in the painterly traditions.

In considering the use of photography in winter we have to start with the basics of the process. The first common photographic images were daguerrotypes. Due to the limitations of the process, which used mercury fumes to create a singular image on a silvered plate, it was rarely used out-of-doors and seldom in winter. It was replaced in the early 1850s by the wet-collodian process which became the standard into the 1880s. The technique produced clear, sharp glass plate negatives which could produce any number of prints, which were primarily printed by sunlight on silver-sensitized albumen paper. Enlarging wasn't practical until the end of the century, so the print had to be the size of the negative, usually about 15 ×

59
**OVERLEAF:**
WILLIAM NOTMAN, HENRY SANDHAM AND EDWARD SHARPE
**Skating Carnival, Victoria Rink, Montreal**
1870, oil on sensitized canvas, 95.2 × 135.9 cm.
Notman Photographic Archives, McCord Museum of Canadian History,
McGill University, Montreal (45.121-I)

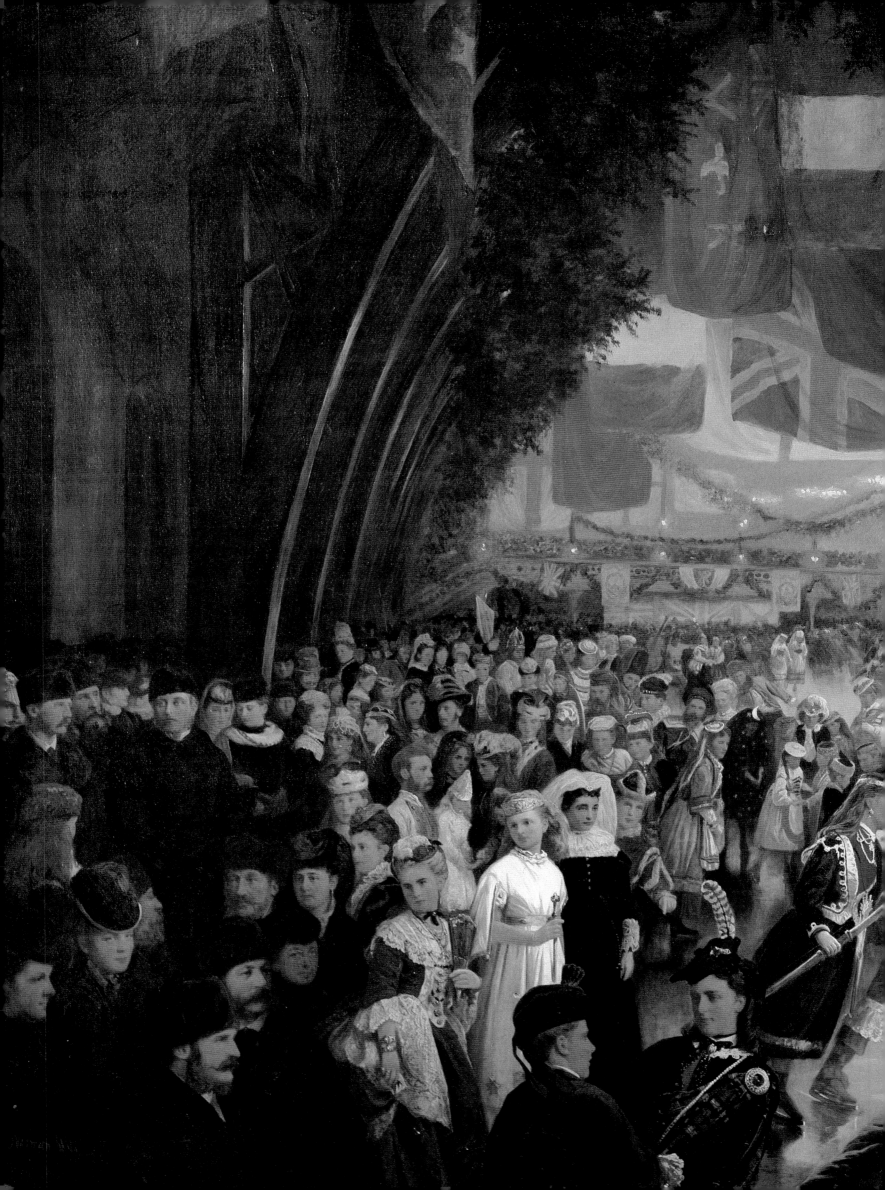

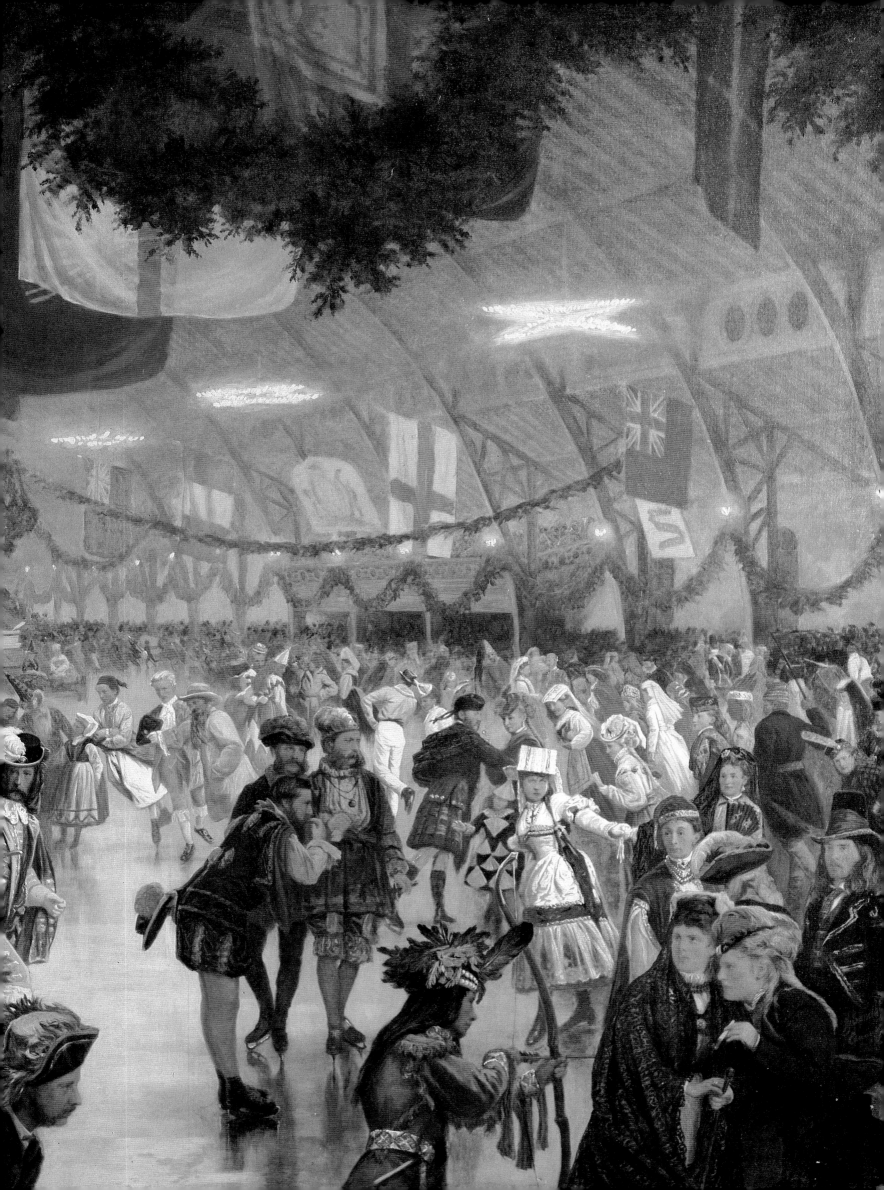

60

**WILLIAM NOTMAN
AND HENRY SANDHAM
Curling in Canada**
1878, composite albumen print,
44.3 × 90.2 cm.
Notman Photographic Archives,
McCord Museum
of Canadian History,
McGill University, Montreal
(48781-II)

20 cm. but could be as large as 50 × 60 cm. As the name implies, the process was wet. In a darkroom or portable dark tent the photographer coated a glass plate with a syrup-like emulsion of gun cotton dissolved in ether and alcohol, then sensitized it in a silver nitrate bath. He exposed the wet plate in the waiting camera and immediately returned it to the dark tent for processing. An awkward procedure in the field, its implications in winter are obvious. Apart from what the cold did to the chemicals or the photographer's hands, it could crystallize the emulsion. Experiments were made using tea or beer as a preservative with varying success. Thomas Mitchell successfully

photographed in the Canadian Arctic in 1875-1876 at –43° C using albumen-beer plates. The difficulty of the process in the cold was probably a major impetus for William Notman to develop his artificial winter environment in the studio. Alexander Henderson did use the standard wet-collodian process for his winter studies, which makes them all the more remarkable. Charles Horetzky used a form of prepared dry collodian plates developed in the early 1870s. His success with this process is notable, for their high failure rate was notorious.

In the 1880s commercially prepared gelatine dry plates were introduced, eliminating the need for the dark tent. With the invention of flexible film supports in the 1890s the gelatine emulsion became the basis for photography as we know it. Throughout this period the sensitivity of negatives was steadily increasing, progressing from a common exposure of eight seconds in 1864 (accounting for the stiff nature of early photography) to one-fiftieth of a second in 1900. The only advantage in winter photography was that the bright snow reduced the required exposure time. It also increased the contrast, however.

All of the photographers we are considering were originally from Scotland but the works of each are remarkably different. Perhaps it's due to his privileged upbringing that Alexander Henderson's photography is most obviously influenced by the pre-Raphaelite style in vogue among the English art photographers at mid-century. His continuing emphasis on landscape photography even after he turned professional in 1867-68 and his dramatic use of light and brooding atmospheric effects equates his work with this group and makes his photographs unique in Canada. The repeated use of winter scenes, like *Edge of the Bush* (Plate 50) and *Valley near Lake Beauport* (Plate 52) reveal his intent to establish typical Canadian subject matter within this genre. His landscapes are a lyrical celebration of the land. *Ice Cone, Montmorency Falls* (Plate 61) is the supreme photographic image of what had become an icon of Canadian winter.

### Alexander Henderson

Born in 1831 at Press Castle, near Edinburgh, Scotland, the son of a wealthy merchant. He emigrated to Canada in 1855 and established himself as a merchant in Montreal. At first considering himself an amateur photographer, Henderson published a number of photographic folios after 1865, all variations on the title and contents of *Canadian Views and Studies by an Amateur*. He was the first North American member of the Stereoscopic Exchange Club in England and his prints are among the very limited amount of Canadian material in the Collection of the Royal Photographic Society. By 1867 Henderson had become a professional photographer, a career he pursued until the late 1890s. During the later part of his career he was Manager of the Canadian Pacific Railway Photography Department. He died in Montreal in 1913.

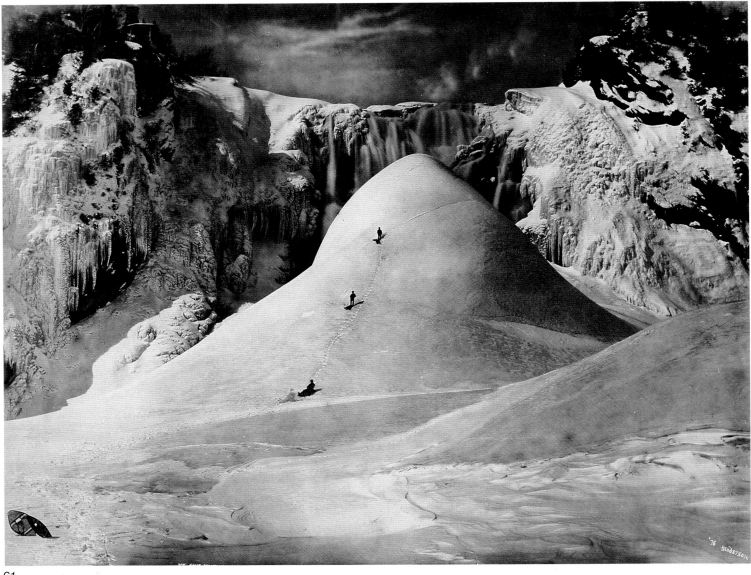

61

ALEXANDER HENDERSON
**Ice Cone, Montmorency Falls**
1876, albumen print, 25.5 × 32.9 cm.
National Archives of Canada, Ottawa (PA 138521)

### Charles George Horetzky

Born in Edinburgh, Scotland in 1838. Educated in Aberdeen and Belgium. Joined the Hudson's Bay Company about 1858 and served at Fort William and, after 1864, at Moose Factory on James Bay as an accountant. He learned photography while at James Bay. Horetzky joined the Canadian Pacific Railway Survey in 1871 as a photographer and was assigned to parties exploring the northern passes through the Rockies. In 1872 he acted as a guide to Sandford Fleming's tour of the west. His career was marred by constant feuding with his superiors over the proposed route of the railway. An arrogant man, he was considered difficult to work with and generally disliked by his peers. He left the survey in 1881 and spent the balance of his working life as an employee of the Government of Ontario. He died in 1900.

Charles Horetzky knew Henderson and it's likely that a number of his prints were made at Henderson's studio. Horetzky's work is more prosaic. He is noted for the bold, clear topographical images he produced in the west during the C.P.R. surveys. An ex-Hudson's Bay Company employee, he had a distinct empathy with the residents of the forts. As well as being excellent topographical views, his *Interior of Fort Edmonton* (Plate 42) and *Cariole and Team, Fort Garry* (Plate 43) illustrate the distinct social hierarchy that existed in the posts. His landscapes are more emotional and in a way similar to Henderson's work, particularly the brooding *On the Peace River in the Heart of the Rocky Mountains* (Plate 51).

## William Notman

Born in Paisley, Scotland in 1826, he emigrated to Canada in 1856 upon the bankruptcy of the family wholesale dry goods business in Glasgow and established his photography business in Montreal. He was an entrepreneur of the first order. By the 1880s the Notman photographic firm had 20 studios established in the main cities in the east, including Halifax, Ottawa, Toronto and Boston. A consummate craftsman and innovative artist, Notman is considered one of the most important photographers in the 19th Century in North America. In the 1860s his reception room was one of the few public exhibition spaces in Montreal. His staff artists were regularly shown along with most of the Montreal artists of the day. Notman died in Montreal in 1891.

William Notman was the pre-eminent 19th century Canadian photographer. This selection of his work concentrates on one small part of his photographic interests which covered virtually all aspects of Canadian life. However, these studio recreations and composite photographs are among his best work.

Utilizing sheep fleeces, coarse-grained salt and splattered negatives, Notman recreated the mythology of winter in his studio. His approach, not only solving the problem of cold for both the photographer and the sitter, enabled him to create the illusion of motion so wanting in photography at the time. The studio tobogganing recreations (Plate 63) and the *Caribou Hunting Series* (Plate 64) which feature Colonel Rhodes, a noted Quebec City politician and gentleman farmer, indicate how important and stylish the image of winter had become in Canadian life. The cream of Canadian society would gather in Notman's studio to be individually photographed in their winter finery, becoming part of one of his famous composite tableaux such as *Curling in Canada* (Plate 60). It must also be acknowledged that this was good business for Notman. Each carefully-posed, perfectly in-focus subject was a potential customer for the final print.

*Skating Carnival, Victoria Rink, Montreal* (Plate 59) was considered his major accomplishment and earned the Notman firm an international reputation. Produced in oils on emulsified canvas with the aid of two of his staff artists, Henry Sandham and Edward Sharpe, this stunning example of the combination of painting and photography remains the quintessential image of winter in 19th century Canada.

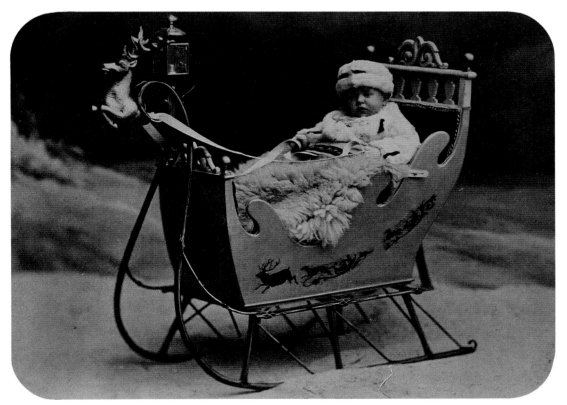

62

WILLIAM NOTMAN
**Mrs. A.J. Corrnieau's Baby**
1878, albumen print, 8.8 × 12 cm.
Notman Photographic Archives, McCord Museum of Canadian History,
McGill University, Montreal (47934-BII)

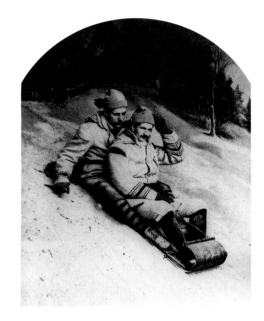

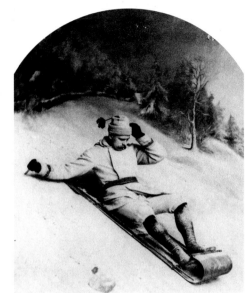

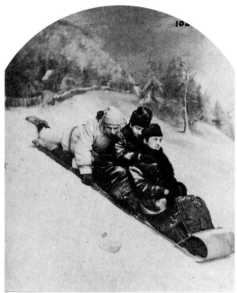

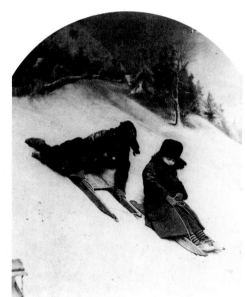

63

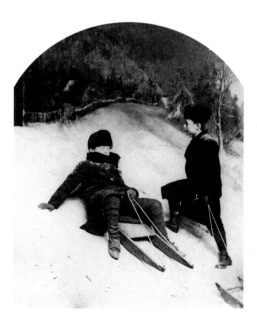

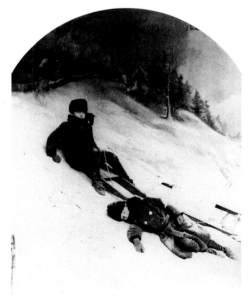

WILLIAM NOTMAN
**Tobogganing**
c.1870, six albumen prints, 10.2 × 7.9 cm. stereo halves
Notman Photographic Archives, McCord Museum of Canadian History,
McGill University, Montreal (1024-1029)

64

**WILLIAM NOTMAN**
**A Page from Captain Thomas Grant's Album**
**(Cariboo Hunting Series)**
c.1866, albumen prints, 50.8 × 57.15 cm.
National Archives of Canada, Ottawa (PA 138585)

65
OVERLEAF:
**F.M. BELL-SMITH**
**Daughters of Canada (detail)**
1884, oil on canvas, 92.4 × 152.7 cm.
London Regional Art Gallery,
gift to the city of London by Anne W.G. Cooper
in memory of her husband
Albert Edward Cooper, 1940

65

F.M. BELL-SMITH
**Daughters of Canada**
1884, oil on canvas, 92.4 × 152.7 cm.
London Regional Art Gallery, gift to the city of London by Anne W.G. Cooper
in memory of her husband Albert Edward Cooper, 1940

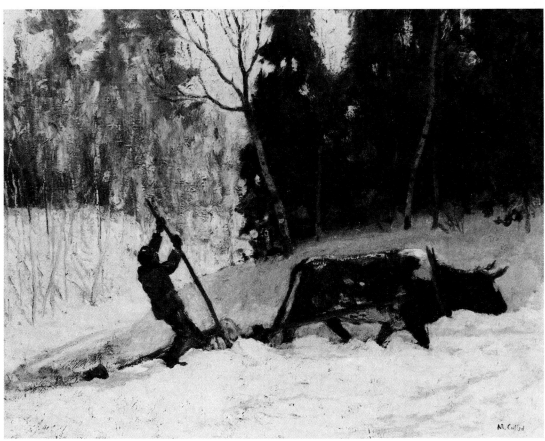

66

MAURICE CULLEN
**Logging at Beaupré**
1896, oil on canvas, 61 × 73.7 cm.
Beaverbrook Art Gallery, Fredericton, N.B., gift of the Second Beaverbrook Foundation

# DENNIS REID
# The Painters
# Following Confederation

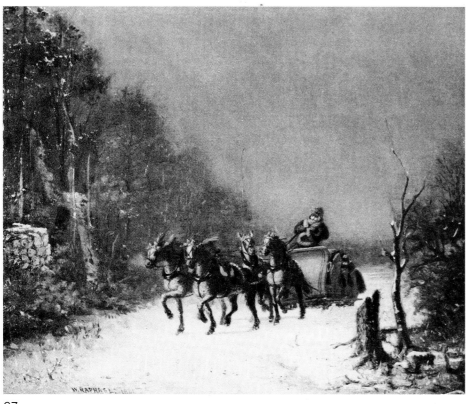

67

**WILLIAM RAPHAEL**
**Royal Mail, New Brunswick**
1861, oil on canvas, 30.5 × 35.6 cm.
Beaverbrook Art Gallery, Fredericton, N.B., gift of Lord Beaverbrook

## William Nicoll Cresswell

Born at Shoreditch, near London, England, 1818, and raised there and at Salford, near Manchester. Nothing more is known of him until 1848 when he emigrated with members of his family to the Canada Company's Huron Tract, settling near Harpurhey, Canada West. Exhibiting first in the mid-fifties, he soon became known for romantic marine landscapes, usually painted in watercolours, but sometimes in oils. He did some studio teaching. Died at Seaforth, Ontario, 1888.

With Krieghoff's example, one would think winter landscape would have become stock-in-trade for Canadian artists. Following Confederation, with the expansion of Canada across the continent and the drive to link the parts of the country by a national railroad, a generation of artists developed, both photographers and painters, who embodied this new national vision in heroic images of Canadian wilderness. Such painters as

Otto Jacobi, Allan Edson and, most notably, John Fraser and Lucius O'Brien dominated the scene during the 1870s and '80s; their expansive portrayals of majestic waterfalls and soaring mountains seeming to encapsulate the glories, potential and actual, of Canada's new nationhood.

Not one winter scene appears to have been included in this unprecedented celebration of pride in the land! There was more than a small amount of Victorian boosterism in their national vision; and the railway entrepreneurs, who saw in their images of a vast, dynamic land the symbols of all they wished to accomplish with their business efforts, patronized them heavily. As well, pictures of the breath-taking scenery opened up by the railroads would attract tourism. It was deemed impolitic to raise the question of winter conditions.

Nonetheless a handful of winter images from some artists of the period survives, isolated "sports," typical neither of their authors' general concerns nor of the fashions of the day. William Cresswell painted a dramatic winter view of the Canada Company's principal port, Goderich (Plate 72). In spite of the bravura gesture of one figure surveying the scene and of the belching smoke of a steam-assisted sailing boat at the ice-piled shore, it is not an image calculated to sell real estate.

68
**OVERLEAF:**
**WILLIAM NICOLL CRESSWELL**
**Goderich, Canada West (detail)**
1858, oil on paper, 49.8 × 70.8 cm.
National Archives of Canada, Ottawa (C-5132)

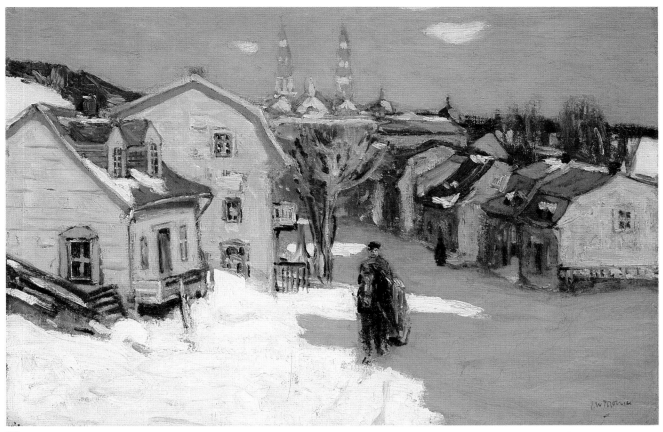

69  JAMES WILSON MORRICE
**Sainte-Anne-de-Beaupré**
1897, oil on canvas, 44.4 × 64.3 cm.
Montreal Museum of Fine Arts, bequest of Mrs. R. MacD. Paterson, Montreal, 1949 (943.785)

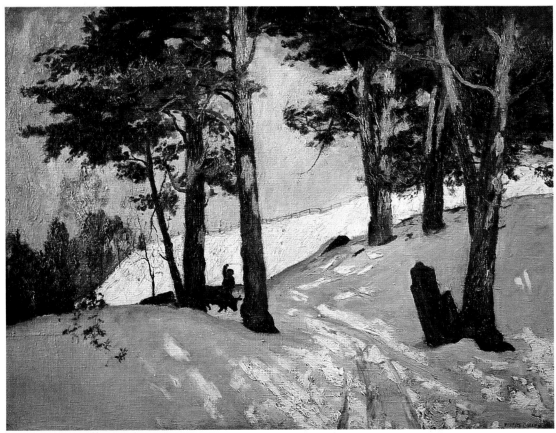

70  MAURICE CULLEN
**Logging in Winter, Beaupré**
1896, oil on canvas, 63.9 × 79.9 cm.
Art Gallery of Hamilton, gift of the Women's Committee, 1956 (56.56.V)

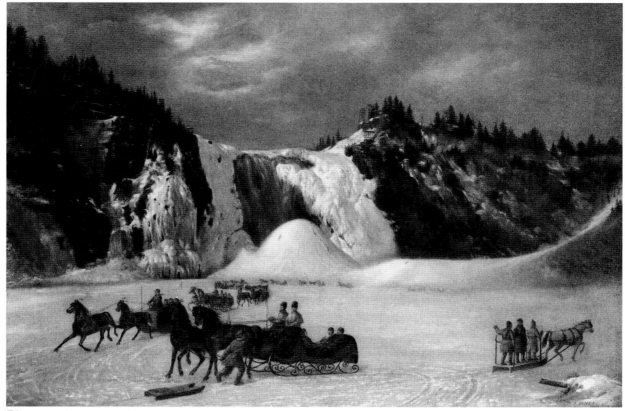

71

JOSEPH DYNES
**Falls of Montmorency, Meeting of the Sleighs**
1867, oil on canvas, 92 × 121.9 cm.
Royal Ontario Museum, Toronto (948.197.1)

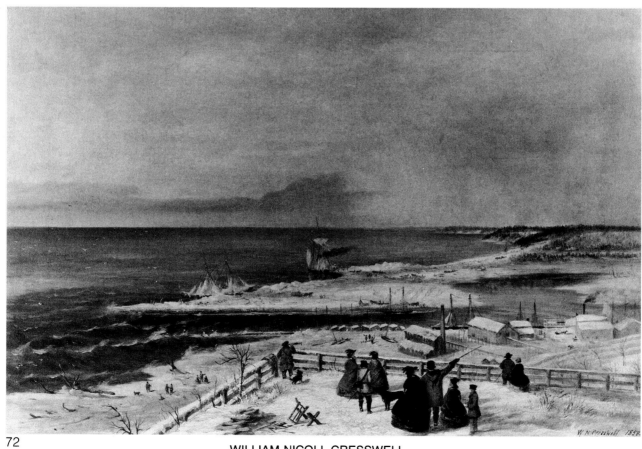

72

WILLIAM NICOLL CRESSWELL
**Goderich, Canada West**
1858, oil on paper, 49.8 × 70.8 cm.
National Archives of Canada, Ottawa (C-5132)

## William Raphael

Born in Prussia, 1833, he studied at the Royal Academy, Berlin, 1851-56. He emigrated to New York City late in 1856, and moved on to Montreal the following spring. He worked between there and Quebec until about 1862 — periodically with the Notman photographic firm — then settled in Montreal. He visited Scotland in 1865. He described himself as an artist and teacher of figure and landscape painting, but is best known for local genre scenes, some of which were published as chromolithographs. Died in Montreal, 1914.

## Joseph Dynes

Born in 1825. Nothing more is known of him until he appears as a member of the Toronto Society of Arts in 1848. A portraitist in St. Catharines, Canada West, 1849-55, he was a portraitist and religious painter in Quebec, 1856-91, although resident in Montreal at least during 1861-65. He also painted landscapes and engaged in the photography business, likely as a photo-tinter, in Quebec, 1857-61, Montreal, 1861-65, and Quebec again, 1865-74. He copied religious paintings for churches throughout the province of Quebec until 1885. Died at Burlington, Ontario, 1897.

## James L. Weston

Born c. 1815, he was apparently in Montreal as early as 1840. Employed by the William Notman photographic firm, finishing photos, 1870-82, he was well-known as an illustrator in Montreal, but also exhibited watercolours and oils, and completed at least one religious programme. Still in Montreal by 1886, he was in Boston by 1889, and New York by 1893. Died, 1896.

Many winter scenes by Montreal-based William Raphael survive. Born in Prussia and trained in Berlin, like Krieghoff he recalled winter genre scenes from his northern European background that he could apply to the Canadian situation. Raphael, however, did little to develop a convincing sense of local colour. Nothing in particular in *Royal Mail, New Brunswick* (Plate 67), more likely a dealer's title than the artist's, suggests Canada, and although the Grimm brothers' beasts of *Habitants Attacked by Wolves* (Plate 56) pursue a characteristic Canadian sledge, in another version they give fright to the passengers of a *troika*.

Some demand continued to call for the by then "classic" images of Canadian winter, those related to sports and recreation. It was in large part satisfied by the ever-expanding photographic firms, although Joseph Dynes, whose career as a painter is intimately related to photography, produced an up-to-date rendition of the *Meeting of the Sleighs* at Montmorency (Plate 57), known in two large versions. Dyne's depiction shows a new concern for naturalism, but in contrasting the grand conveyances of the tandem club members with the sledge of the habitants, he has stuck to conventions.

I must mention one other image of the immediate post-Confederation years. *Young Canada* (Plate 74) is a print produced in 1872 to promote local artistic activities. James Weston, involved in aspects of the photographic business, worked with Notman in Montreal. His print relates more to the naturalistic studio tableaux Notman was then producing than it does to the era's painting concerns, which were focussed almost entirely on landscape.

A younger generation of artists challenged the landscape emphasis, turning to figure painting in the European tradition as the Paris academies taught it. During the '80s every ambitious young Canadian painter spent a year or two in Paris and, as a result, Canadian art was changed utterly. The figure became paramount, and the only alternative to portraiture was the studio-posed tableau. Snow lay outside the concerns of most Canadian painting. The rare exceptions to this trend depended on issues peripheral to the artistic thrust of the day. F.M. Bell-Smith's *Daughters of Canada* (Plate 65), like the Weston print it so resembles in sentiment, relates to popular photographic composites. Bell-Smith worked as a photographer for almost fifteen years before teaching provided a subsidy for the painting which had always been his first love. *Daughters of Canada* portrays some of his students in London, Ontario, and there can be little doubt he intended the wintry setting to underline their "Canadianness."

73
**OVERLEAF:**
**WILLIAM BRYMNER**
**Champ-de-Mars, Winter**
1892, oil on canvas, 74.9 × 101.6 cm.
Montreal Museum of Fine Arts,
bequest of Mrs. R. MacD. Paterson,
Montreal, 1949 (949.1008)

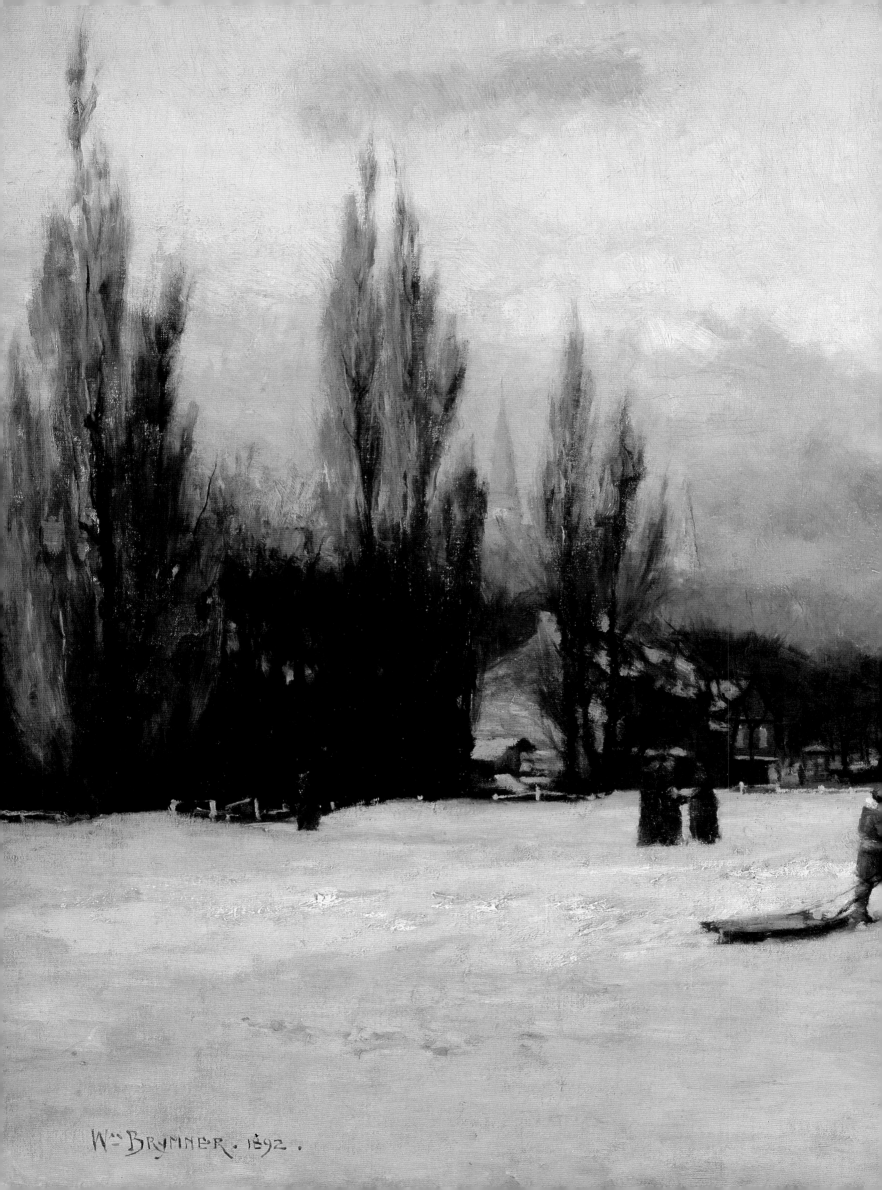

W^m BRYMNER. 1892.

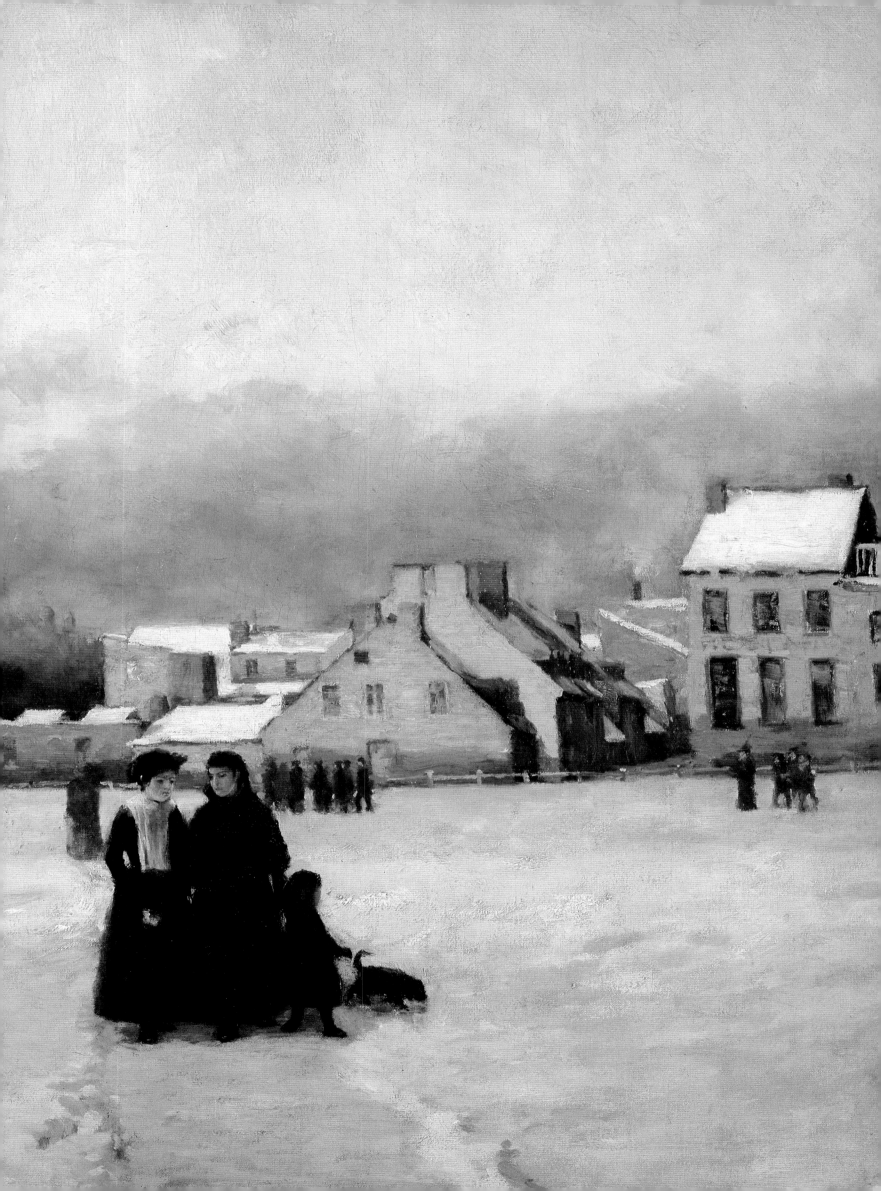

**Frederic Marlett Bell-Smith**
Born in London, England, 1846, his father, John, was a portraitist. Said to have studied at the South Kensington Art School, he followed his family to Montreal in 1867, where he was employed by James Inglis, photographer, 1867-71. He moved to Hamilton, Ont., in 1871, to operate a branch for Inglis, then moved to Toronto in 1874, and back to Hamilton, 1879-81, working with photographers and doing some illustration work. He visited Paris in 1881, and studied at the Colarossi Academy, then settled in London, Ont., where until 1888 he was an art teacher at Alma College in nearby St. Thomas. He painted summers in the Rocky Mountains, 1887-90. He moved back to Toronto in 1888 to be principal of the Toronto Art School, Western Branch. In London, England, and Paris 1891-92, he returned to London for short visits in 1895, 1896, 1902. Well-known for his mountain landscapes he returned to the Rocky Mountains the summers of 1898-1900, 1909, 1914, 1918. Died in Toronto, 1923.

**William Brymner**
Born at Greenock, Scotland, 1855. His family emigrated to Melbourne, Canada East, in 1857, settled in Montreal within the next ten years, and moved to Ottawa in 1870. He studied at the Académie Julian, Paris, 1878-80, and was appointed master of the Ottawa Art School in 1880, for one year. He returned to France the summer of 1881, and 1883-86, with the period May-November 1884 in Yorkshire. He visited the Rocky Mountains the summer of 1886, and that fall was appointed principal of the Art Association of Montreal School, a position he held until 1921. One of the notable figure painters of his day, he was president of the Royal Canadian Academy, 1909-17, and a close friend of both Cullen and Morrice. He returned to Europe 1891, 1897, 1902, 1908, and retired there in 1923. Died at Cheshire, England, 1925.

**James Wilson Morrice**
Born in Montreal in 1865, he studied law in Toronto, 1882-89. Travelling to London in 1890, he moved to Paris the fall of 1891, enrolling briefly in the Académie Julian. He studied landscape painting with Henri Harpignies in 1892. With Paris as his base, he travelled for sketching in Normandy, Brittany, the south of France, Italy, and North Africa. He returned to Montreal for visits in 1894, winter 1896-97, winter 1899-1900, 1905, winter 1908-09, 1910, winter 1911-12, winter 1914-15. In addition to North Africa, he visited the Caribbean frequently after 1915. Involved with many of the leading painters of his day in Paris, his own work was valued by collectors and critics. Died in Tunis, 1924.

*Champ-de-Mars, Winter* (Plate 73) is another of the rare winter scenes by a Canadian who trained in Paris in the '80s. William Brymner, a pioneer of those who sought French training, as principal of the Art Association of Montreal School greatly influenced succeeding generations in that direction. This did not mean the values of French academic figure painting dominated Canadian art for decades, however, because Paris attitudes towards the figure, landscape, and naturalism were changing, changes exemplified by the Impressionists who first exhibited together in 1874. Brymner's painting, set in the same Montreal square as James Duncan's *Quebec Tandem Club* (Plate 21) a half-century before, points a new direction by the way the figures, while carefully studied, do not dominate the image. The interest it reveals in the myriad effects of the raking light of mid-winter Montreal is the true subject of the painting. It signals another shift in the function of art in Canada, and the appearance of new models that would have far-reaching consequences.

The shift was not dramatically rapid. It was a few years before evidence of a radically different attitude to painting became clear. Maurice Cullen and his friend James Wilson Morrice were both friends of William Brymner. Cullen travelled to Paris in 1888, studying there until resettling in Montreal in 1896. Morrice, also a Montrealer, arrived in Paris in 1891, studying briefly at the Académie Julian, then with the venerable landscape painter, Henri Harpignies. He returned home for a brief visit in 1894, and then for a longer stay the winter of 1896-97.

Brymner had introduced Cullen to the region of Beaupré, near Quebec. Already a favourite sketching spot for the most advanced painters of Montreal and Toronto, it – and the habitant way of life – reminded them of their favourite sketching spots in Brittany, locations famous because of the new French enthusiasm for outdoor sketching. Cullen worked in Beaupré in the summer and early winter of 1896. *Logging in Winter, Beaupré* (Plate 70) was later recognized as a great accomplishment of his career. A stunning picture, it tells us almost nothing about logging in Beaupré. A driver and his ox, which we see just rising over a hill, are the dark perfunctory focus of an image that revolves around the formal balancing of the contrast between brilliant white winter light on snow with delicate blues in the foreground shadows. He matches his boldness in presenting this balance with the way he has applied his paint, its viscous nature openly declared in a rough relief that scintillates with the flashing light of the sun on broken crusted snow.

## Maurice Galbraith Cullen

Born at St. John's, Newfoundland, 1866, but moved with his family to Montreal in 1870. Studied at the Institut National, and with the sculptor, Louis-Philippe Hébert, 1884-87. He travelled to Paris in 1888, where he enrolled in the Académie Julian, and continued there and at the Académie Colarossi in 1889, then studied at the Ecole des Beaux-Arts, 1890-92, returning to Montreal in 1895. Back to France for the spring of 1896, he settled in Montreal again in the summer, and remained there four years with periodic sketching trips to Beaupré and elsewhere. He preferred figure painting, but pursued landscape because of its popularity. An official war artist, 1918-20, he worked in London, France, and Belgium. He returned once again to Europe the summer of 1925, then moved to Chambly on the Richelieu River in 1926, where he died in 1934.

Cullen returned to Beaupré again in January with Morrice, sketching there and around Quebec until March, producing more paintings of brilliant light on deep, disturbed snow that are among his finest pictures. Morrice also revelled in the experience, and produced a small number of particularly luminous pictures. *Sainte-Anne-de-Beaupré* (Plate 69) is as candid as a snapshot, showing the famous pilgrimage church hovering over the village in the distance and an approaching work sledge, a vehicle unchanged from the one James Peachey depicted over a century earlier. The unconcern to show the sledge clearly, to inform the viewer of any aspect of the "meaning" of this object,

forces upon us – even more strongly than in Cullen's work – the primacy of the physical reality of paint in its myriad hues, its substantial yet malleable nature, and its sheer beauty. The picture celebrates Morrice's perception of a world conveyed to his eye entirely by light, translated to the canvas entirely by paint. The economy of its conception, coupled with the possibilities of its technique, would inspire most of the younger painters in the first decades of the new century and assure that landscape and, indeed, the winter landscape would to an unprecedented degree become the typical image in Canadian art.

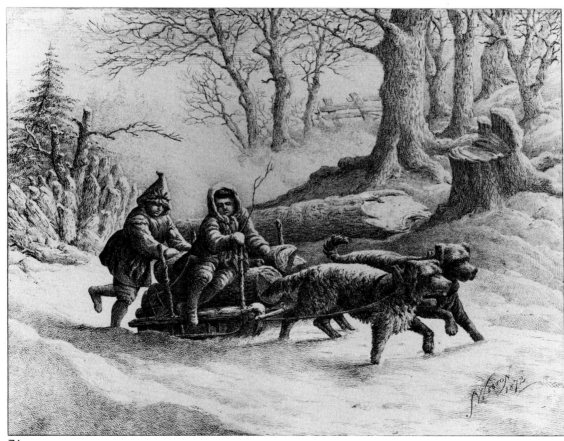

74

**JAMES WESTON**
**Young Canada**
1872, Leggotype, 24.2 × 30.6 cm.
National Archives of Canada, Ottawa (C-41399)

EDITOR:
Jon Whyte

DESIGNER:
Robert MacDonald / MediaClones Inc.
Toronto and Banff

TYPESETTING:
New Concept, Toronto

SEPARATIONS:
United Graphics, Calgary

PRINTING:
Agency Press, Vancouver

RESEARCH ASSISTANCE:
Marg Meikle
Gerard Curtis, University of Calgary
Claire MacDonald, National Library of Canada

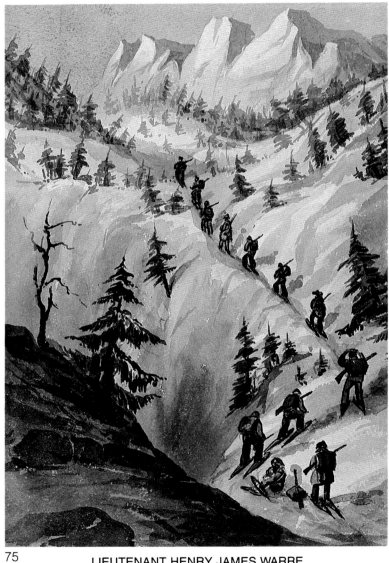

75

LIEUTENANT HENRY JAMES WARRE
**Ascending Rocky Mountains on Return to Canada**
1846, watercolour, 25.4 × 17.4 cm.
National Archives of Canada, Ottawa (C-27586)